IMAGES
*of Modern America*

# MOUNTAIN CLIMBING IN WASHINGTON STATE

IMAGES
of Modern America

# MOUNTAIN CLIMBING IN WASHINGTON STATE

Donald R. Tjossem

ARCADIA
PUBLISHING

Published by Arcadia Publishing
Charleston, South Carolina

Printed in the United States of America

Library of Congress Control Number: 2014948172

For all general information, please contact Arcadia Publishing:
Telephone 843-853-2070
Fax 843-853-0044
E-mail sales@arcadiapublishing.com
For customer service and orders:
Toll-Free 1-888-313-2665

Visit us on the Internet at www.arcadiapublishing.com

*This book is dedicated to the Seattle Mountaineers and the
Bellingham Mountain Rescue Council, without whose inspiration
and teachings this book could never have been written.*

# CONTENTS

# ACKNOWLEDGMENTS

To those trailblazers that have gone before, making trails, researching, writing, and taking photographs, I owe a debt of gratitude. This book could never have been written without those individuals who did the original discovery work of mountain climbing in Washington State.

The Tacoma Public Library staff in the Northwest Room has always been wonderful in answering to the best of their ability any questions or offering assistance that was needed for this publication. Thanks go out to all of the volunteers that participate in the Mountaineers program in Washington as well as the dedicated participants in the Mountain Rescue Association. Without these two outstanding programs in our state this book would have been impossible.

The editors at Arcadia Publishing who assisted me on this project and brought it to conclusion were Rebecca Coffey, Matt Todd, and Mike Litchfield. Their support of this project is appreciated.

Special thanks go to my wife, Becky Alexander, who encouraged me to write this book, very well knowing how much of my time it would take and how much of her time it would take making my writing appear much better than it really is.

Unless otherwise noted, the images in this book are courtesy of the author.

# INTRODUCTION

This book is meant only as a sample of views one may experience in the mountains of Washington State. It is meant in no way to be a guidebook or a mountain climbing manual, although there may be some elements of each in some of the image captions throughout.

There are four distinct regions of mountain climbing within Washington, and this book will share images from each of the regions. The North Cascades National Park and surrounding area is climbing at its most rugged, as access and developed routes may be very hard to come by in the remote region. To the south in the Mount Rainier and Mount St. Helens area, the weather is milder, and the climbing areas are much more popular and accessible to climbers. The Olympic Peninsula offers the Olympic National Park as a climbing option that can take a person from virtually sea level up to an elevation of 7,954 feet. Eastern Washington climbing is mostly rock oriented and offers many challenging faces for those interested in rock climbing.

It is important to note that this book presents images mostly taken on pleasant days when the views were optimal. That is not reality for everyday climbing in Washington. Many days are clouded over even if it is not raining. Many trips were taken when the camera was not even taken out of the case, and the images and endurance of the clouds and rainy weather have long been forgotten.

Climbing is a sport that was imported after the first explorers came to Washington. Early Native Americans had no need to climb any higher than where the vegetation and game were for their sustenance. Some mountains were part of their folklore, and often spirits were thought to reside in the higher elevations, especially if there was the scent of sulfur or any sign of smoke billowing from a crater.

These images are very introductory ideas of the beauty of Washington's mountains. One is encouraged to explore them up to the extent of his or her ability to fully enjoy the sights. If this book encourages a person to seek out a climbing program to further personal enjoyment of the scenery and all else the mountains of Washington have to offer, then this writing will not be in vain.

There are thousands of magnificent peaks in the Cascade Range, Olympic Peninsula, and eastern Washington to fit everyone's climbing style and ability. It is very important that proper training and safety procedures be in place before any climbs or outings are attempted in the areas shown in this book. This scenery is not available on a casual trail hike or alpine scramble.

Hopefully this book will inspire individuals to participate in the great out of doors that the state of Washington has to offer. A few words of caution should be entered here no matter how far you decide to venture into the mountains. Probably the first is that groups are far better than solo ventures in terms of safety. Is someone is injured or can no longer move somebody need to go for help. Cell phones are certainly nice but cannot always be depended upon. Be sure to advise someone of your basic itinerary and return date so that Mountain Rescue will have a basic idea of where to start searching if your party does not return in a timely manner.

As far as what equipment to carry, the Mountaineers have what they call the "Ten Essentials" that include:

1. Navigation (map and compass)
2. Sun Protection (sunglasses and sunscreen)
3. Insulation (extra clothing)
4. Illumination (headlamp/flashlight and extra batteries)
5. First-aid supplies (first-aid kit)
6. Fire (waterproof matches/lighter/candles)
7. Repair kit and tools (knife or multi-tool)
8. Nutrition (extra food for a day)
9. Hydration (extra water)
10. Emergency shelter (tent, tarp, bivy, or reflective blanket)

The above are the basics for any outdoor trip and should be adjusted as to the length, difficulty and size of the group. Too much is far better than too little. Weather in the state of Washington is very unpredictable and can change very fast, especially at the higher elevations. The mountains quite often make their own weather, regardless of forecasts that were heard before the trip begins. Most of the images in this book were taken in very good weather and hopefully do not leave the impression that it is always like that in the mountains.

One lasting comment to make on safety that is important but that many beginning climbers overlook is that the easiest part of the climb is getting to the summit. The hardest part of the climb is quite often getting down when the group is tired, in a hurry, and possibly the weather has changed significantly from when the trip started.

# One

# THE EARLY YEARS

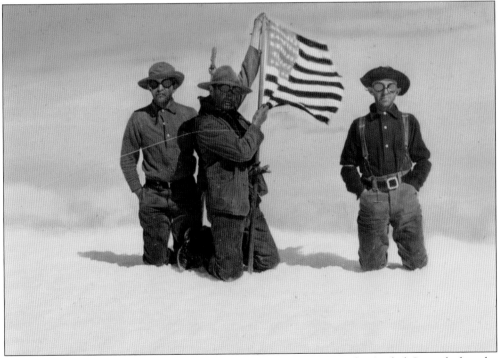

This image was taken on the summit of Mount Baker in June 1908 by Asahel Curtis before the 1908 Mountaineers outing for that summer. Typically the leaders of a climb will scout out an ascent they are leading before the actual event just to familiarize themselves with the route. If this is not their first time, leaders will check to see if there have been any geological changes that need to be considered for their climb later. This was certainly a significant event for them, as flags are usually not carried to the summit for photographic opportunities in Washington climbs. There are currently very few occasions where one would even be carried on significant international climbs. There are only 46 stars on this flag. An alpenstock is used as a flagpole, and hats to protect the climbers from the sun are used, rather than helmets to protect them from rock and ice. (Courtesy of the Tacoma Public Library.)

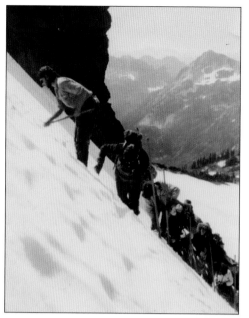

This early image was taken on a steep snow slope about 1905 on Unicorn Peak, just south of Mount Rainier in the Tatoosh Range. It appears climbers are using alpenstocks instead of ice axes, as would be used in modern-day climbing. There were no hard hats used at this time, an item almost always used regularly nowadays. Some of the climbers appear to be in cotton clothes; waterproof and windproof fabrics were dreamed of in those days. Other images in this series will show how the first groups of climbers approached climbs in ways considered quite dangerous by today's standards. These early climbers did not have the benefit of modern safety-oriented mountain climbing courses as offered by many organizations and guide services today. They truly were climbing pioneers in Washington. (Courtesy of the Tacoma Public Library.)

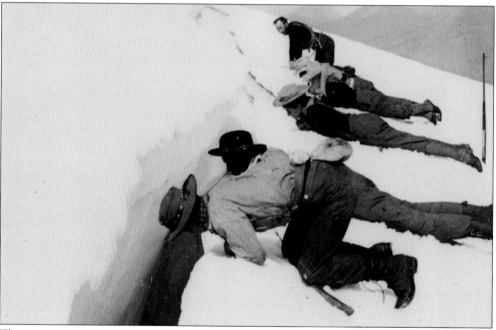

This interesting image shows a group of climbers in a precarious position, peering over the edge of a deep crevasse, apparently out of curiosity. This image was taken about 1906 on a glacier known as "Goat Peak Glacier." It is identified as being on one of the peaks in the Goat Rocks Wilderness area between the Gifford Pinchot National Forest and the Snoqualmie National Forest. This type of behavior would never be done in modern climbing as it is obviously very dangerous. These climbers have no helmets on, they are not roped together, and they are far too close to the edge of this crevasse. Any modern climbing program would advise of the hazards of this type of activity on day one of "snow practice" or "snow climbing." Sometimes individuals fall into a crevasse like this and are never retrieved, even today. (Courtesy of the Tacoma Public Library.)

This photograph from a Mount Baker trip in 1906 shows two climbers in a perilous position working their way up a steep slope as they approach the summit. This image demonstrates a dangerous situation for these climbers, although they are roped together for this portion of the climb. On this trip, the lead climber was brave enough to go on ahead by himself and secure the lifeline at a higher level for the remaining climbers to use. (Courtesy of the Tacoma Public Library.)

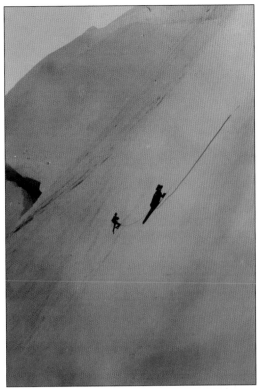

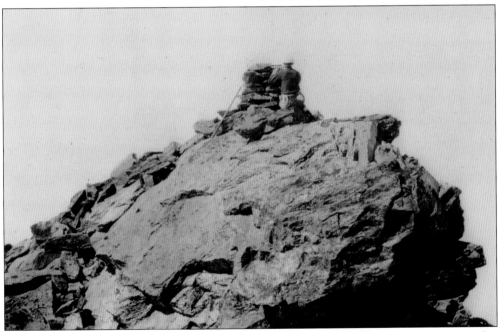

This image is of W.M. Price building a cairn on top of Mount Shuksan to commemorate his climb with Asahel Curtis in early August 1906. They stayed overnight on the summit of Mount Shuksan for this trip because it took so long. This cairn is much larger than most that are seen on the summits of these peaks today. (Courtesy of the Tacoma Public Library.)

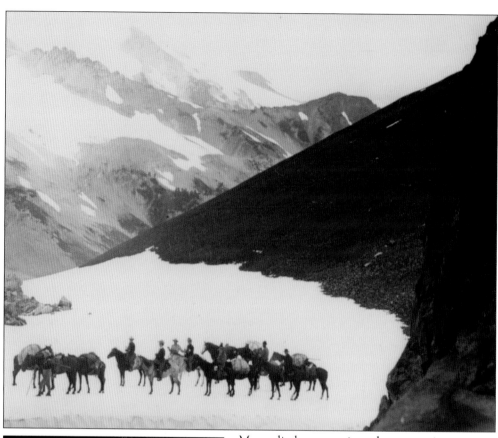

Many climbers went into the mountains on horseback to get to the base camp in the early days. With modern roads and trails in place now, there is little need for horses in climbing. This image was taken about 1906 somewhere near the south fork of the Tieton River in the Goat Peaks Wilderness area at an elevation of about 7,000 feet. (Courtesy of the Tacoma Public Library.)

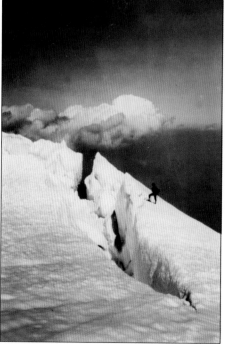

This image was used in several early publications about climbing, including the March 1907 issue of *Mazama* by Gertrude Metcalfe. The man standing unroped and very close to the edge of the crevasse may be F.H. Kiser, the leader of this early ascent of Mount Baker. (Courtesy of the Tacoma Public Library.)

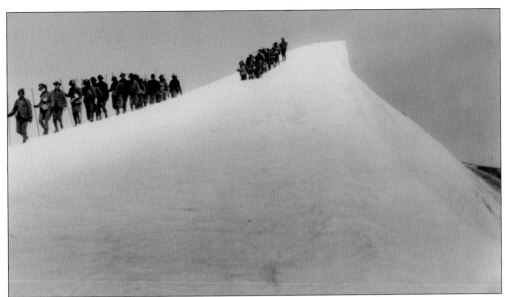

These images, taken on the 1908 Mountaineers climb of Mount Baker, once again show early climbing techniques that are much different from present-day climbers' procedures. Again these climbers are unroped except for when they are using the ropes for assistance in negotiating the difficult areas in the crevasses. Part of the danger that may not have been as apparent to them as it would be to modern-day climbers is the fact that so many of them are standing close to the edge of the crevasse; their added weight could cause it to collapse. Unseen snow bridges could easily collapse under the weight of many climbers. (Both, courtesy of the Tacoma Public Library.)

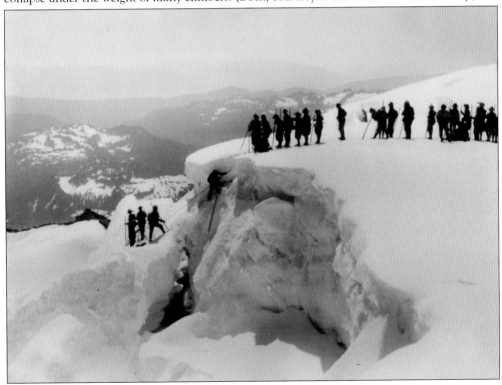

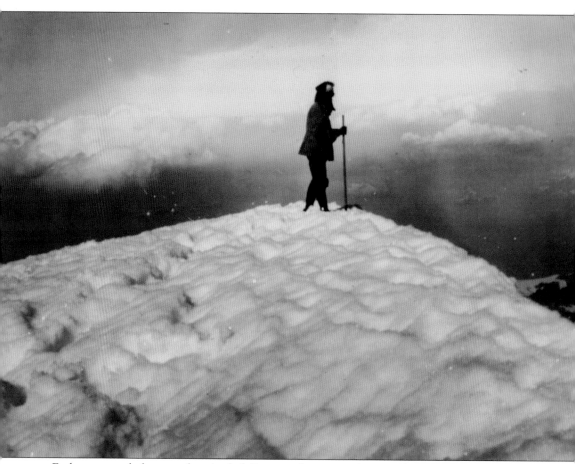

Early renowned photographer Asahel Curtis is shown standing on the summit of Mount Baker upon the completion of the Mazamas' Mount Baker climb of 1906. This photograph is credited to the leader of the climb, F.H. Kiser, according to the March 1907 issue of *Mazama* magazine. (Courtesy of the Tacoma Public Library.)

These two images show climbers on Mount Baker's Boulder Glacier in early 1908. Notice that these climbers are on a glacier using much different standards than what are currently used. For one thing, they are not roped up for protection in case someone falls, there were no hard hats then, and alpenstocks are being used rather than any kind of ice ax. Another dangerous consideration is that they are putting a lot of unnecessary weight on the ice formations when they stand in large groups. Climbing protocol has significantly improved over the last 100 years. (Both, courtesy of the Tacoma Public Library.)

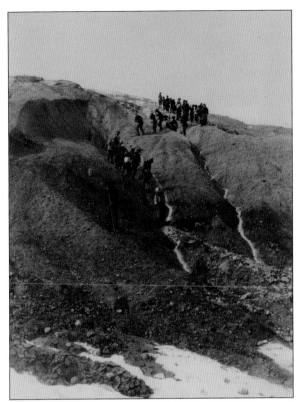

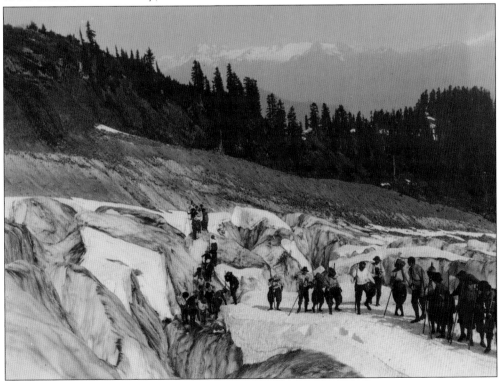

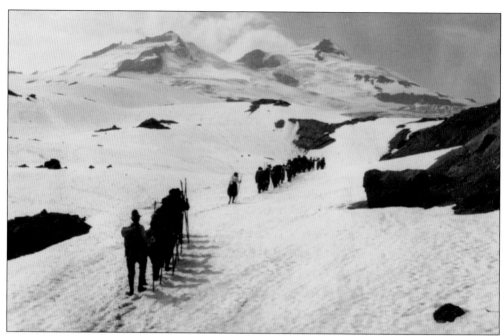

Unroped and large groups were the norm for early mountaineering in Washington on steep snowfields. These images show the 1908 Mountaineers climb of Mount Baker, with participants using the typical alpenstocks of the time. It was not until the 1970s that climbing groups were generally limited to a party of 12 both for safety and environmental considerations. The smaller group provided a better experience for all involved, and leaders were able to focus more on what a leader should during a climb rather than large group dynamics and considerations. (Both, courtesy of the Tacoma Public Library.)

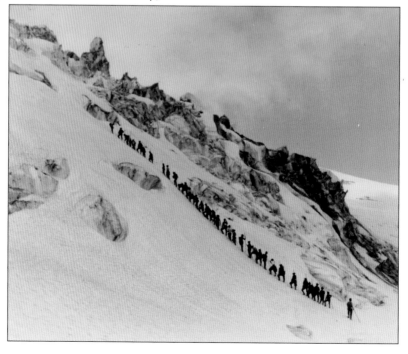

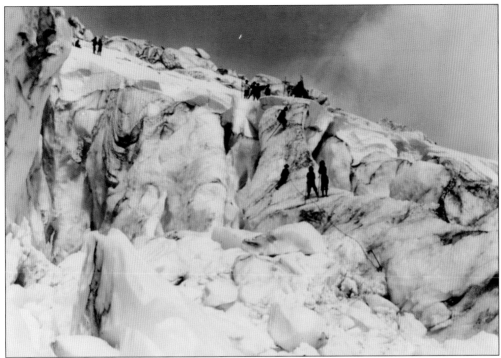

This image shows the challenges of ascending heavily glaciated areas of Mount Baker. These mountaineers are working as a team to safely climb Boulder Glacier early in the climb before getting to the steepest part of the trip. Navigating the glaciers is usually the most dangerous part of any major mountain climb. (Courtesy of the Tacoma Public Library.)

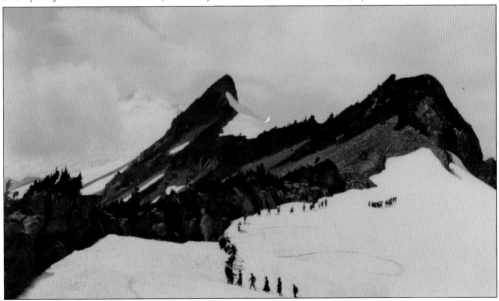

Pictured here in 1906, these early Mazama climbers are crossing a snowfield on the way up to Colman Pinnacle. Colman Pinnacle is at the far end of Ptarmigan Ridge on the way up to the mountain. The leader of this climb was F.H. Kiser, a well known Mazama leader of climbs in the early times. (Courtesy of the Tacoma Public Library.)

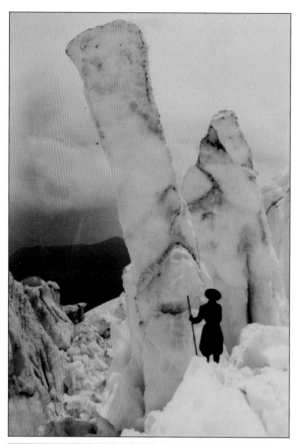

This image shows how dramatic ice formations became on highly glaciated routes in the Cascades before global warming caused the glaciers to retreat. This climber, who appears to be a woman wearing a dress as they did when they climbed in the early days, is dwarfed by this ice formation on Mount Baker. (Courtesy of the Tacoma Public Library.)

The Mazamas, a Portland, Oregon, mountain-climbing organization, did much of the early climbing in Washington. Many summit registers are found in containers such as this one, which was atop Glacier Peak, and hold primary documentation of summit climbs through the years.

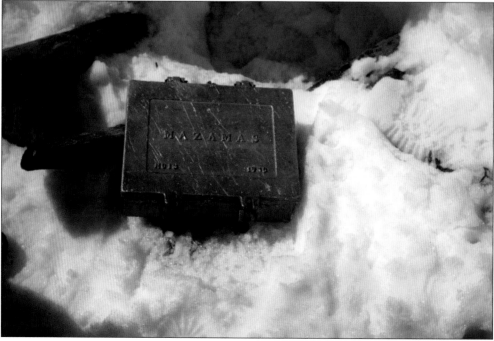

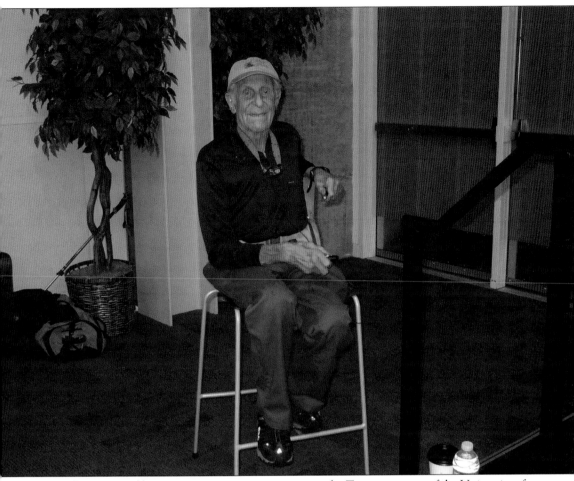

Fred Beckey, pictured here prior to giving a presentation at the Tacoma campus of the University of Washington in March 2014, is considered the preeminent explorer and investigator of the Cascade Range wilderness. He has more first ascents than anyone in the area and has written many books on climbing. One of his first is referred to by mountain climbers as "Beckey's Bible."

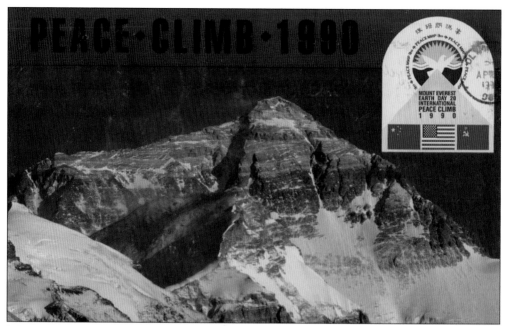

Mount Rainier was the training ground for climbers from Russia, China, and the United States for the Earth Day 20 International Peace Climb in 1990. Jim Whittaker, a noted Washington climber who was the first American to climb Mount Everest, made the arrangements for this undertaking involving a group of 30 climbers from three countries. When the climb was completed, 20 climbers reached the summit, and it was the most successful Mount Everest expedition in history. The front and back of a postcard that was mailed from Lhasa, Tibet, in China, on April 23, 1990, with the climbers' signatures, are shown here.

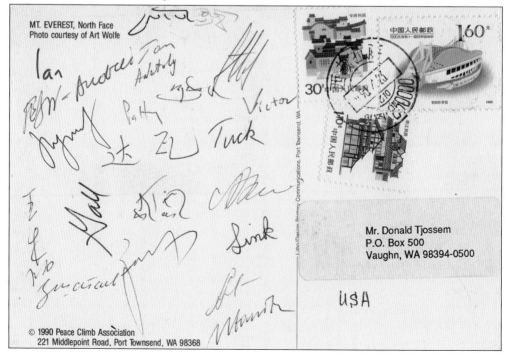

# Two

# Northern Washington/ Mount Baker Area

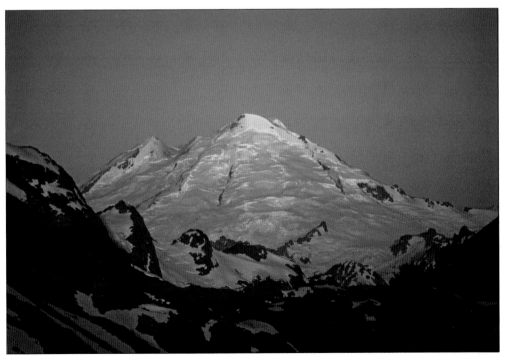

This photograph shows what the popular Easton Glacier route looks like on Mount Baker from the south. The climb is a straight on and up route with few navigational issues, except for working around crevasses and icefalls. Some hardy skiers may also be using this route up Mount Baker. The best climbing season is from May through July.

Mount Baker is shown here from the southern side as it would be climbed ascending the North Ridge, shown just to the right of the Cockscomb on the left ridge, or the Coleman Headwall straight on, which is one of the more challenging routes. This route is dangerous due to icefall and should only be done by proficient teams. The first ascent was by Les MacDonald and Henry K. Mather in April 1958.

Getting up to the glaciers where the going is on ice and snow involves climbing through snow couloirs and navigating other areas that are not always hospitable to climbers. These two climbers chose not to rope up for this part of the trip as they did not feel it a dangerous or exposed situation at the time.

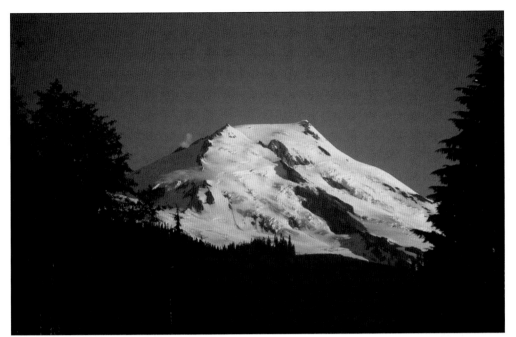

This photograph of Mount Baker from the southeast shows the Easton Glacier route to the left of Sherman Peak, which stands at 10,160 feet on the left of the summit. Grant Peak is shown on the top right-hand side of the summit. Talum Glacier is shown in the foreground, and Boulder Glacier is shown on the right-hand side.

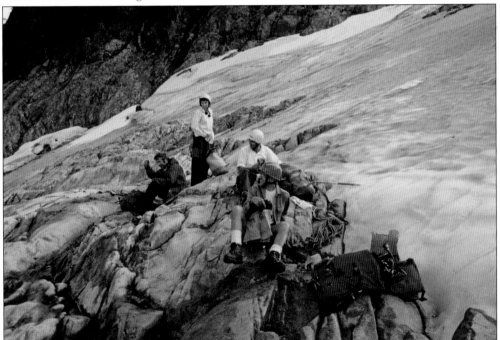

Climbers are taking a break and discussing the route to be taken down the Nooksack Cirque. This climbing is very dangerous and should only be undertaken after a person has completed a significant mountain climbing program using full climbing regalia.

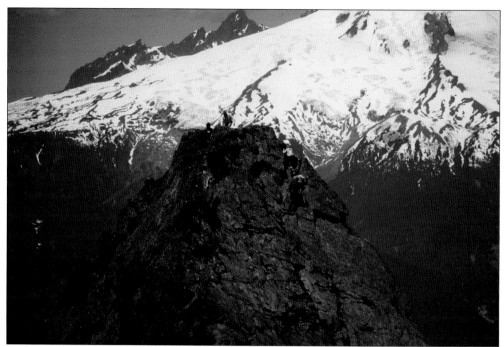

This image shows climbers atop North Twin Sister Peak at an elevation of 6,640 feet. This climb is a popular one-day climb that can be done as an alpine scramble for properly equipped and trained mountaineers. It is not recommended for beginners, although some will attempt it. The views of Mount Baker and the surrounding area are outstanding.

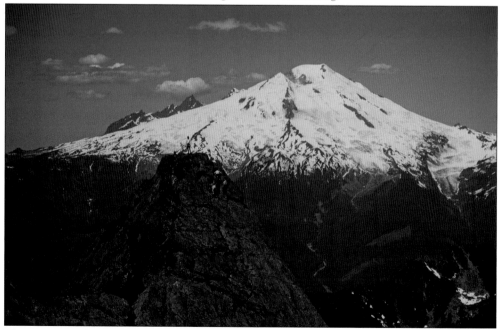

This image is taken from the same location (North Twin Sister Peak) as the one above and shows Mount Baker in the background with some of the area's other outstanding scenery. Ice axes are advised if this trip is done before July, and hard hats should always be used.

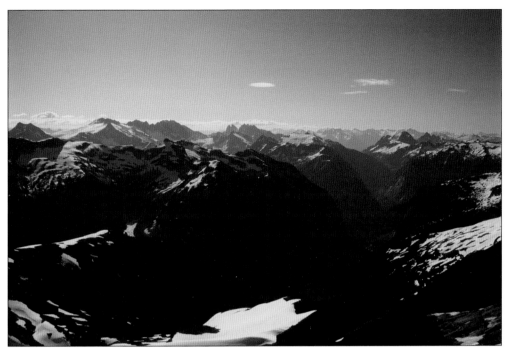

Looking to the southeast of the North Twin into the Cascade Range, one gets an idea of the vastness and size of the range. Some of the peaks seen in this image may have never been named or even climbed, simply because there are so many.

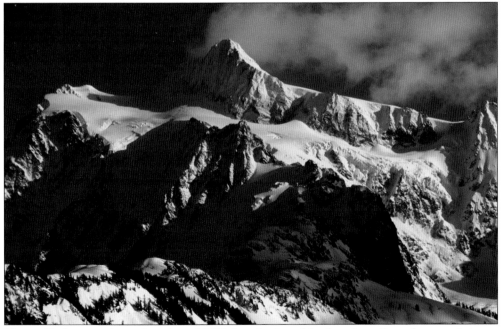

Mount Shuksan, with an elevation of 9,131 feet, is viewed in the winter from the west. It is not normally viewed from the east, which has no automobile access. The Upper Curtis Glacier is seen across the mountain from this viewpoint. The route to the summit is by the couloir on the right side.

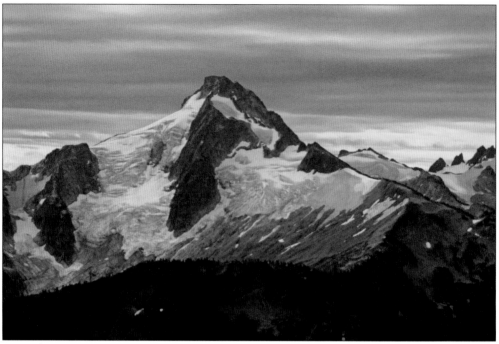

Icy Peak, at an elevation of 7,073 feet, is seen by climbers before descending down the Nooksack Cirque on the Nooksack Glacier. This peak is located at the head of the Nooksack River and Pass Creek fork of the Baker River. The name Icy Peak is deceptive, as the peak is mostly volcanic material. When Herman Ulrichs ascended this peak in 1935, there was a tin can on the summit, but there is no other evidence available as to who made the first ascent.

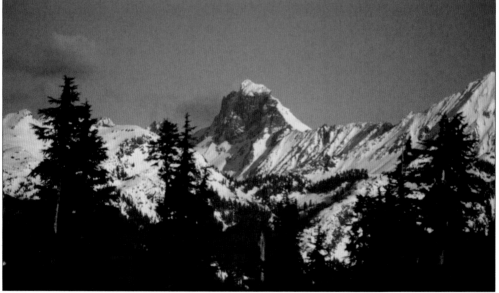

American Boarder Peak is very seldom climbed due to the remoteness and difficulty of the climb. Rock fall is a constant threat to climbing parties, and the route to the summit is not easily discernible. At just less than 8,000 feet in height, it also falls below what some climbers would call a "trophy peak."

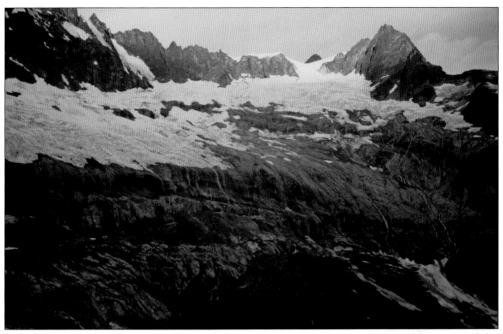

Here is an image looking back from the bottom of the Nooksack Cirque. The source of the Nooksack River is at the bottom of the cirque, and the water is icy cold. At this point everyone is happy to be off the ice and on solid ground.

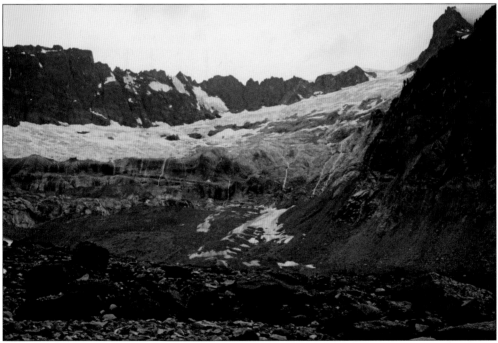

From the bottom of the Nooksack Cirque, Icy Peak is seen from below. From this vantage point, the falling ice is very loud and makes one nervous to think about what has just been crossed. Mountain climbers are always aware that "the mountain may move" and take as many precautions as possible to avoid disasters.

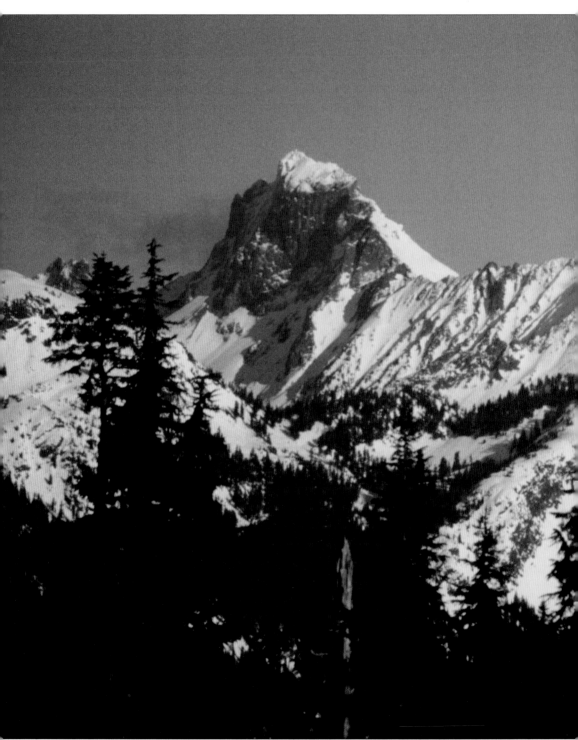

American Border Peak is on the left with an elevation of 7,994 feet, and Mount Larrabee (Red Mountain) at an elevation of 7,861 is seen to the right. American Border Peak is less than one-third of a mile south of the international boundary, and the first ascent was made by Alec Dalgleish,

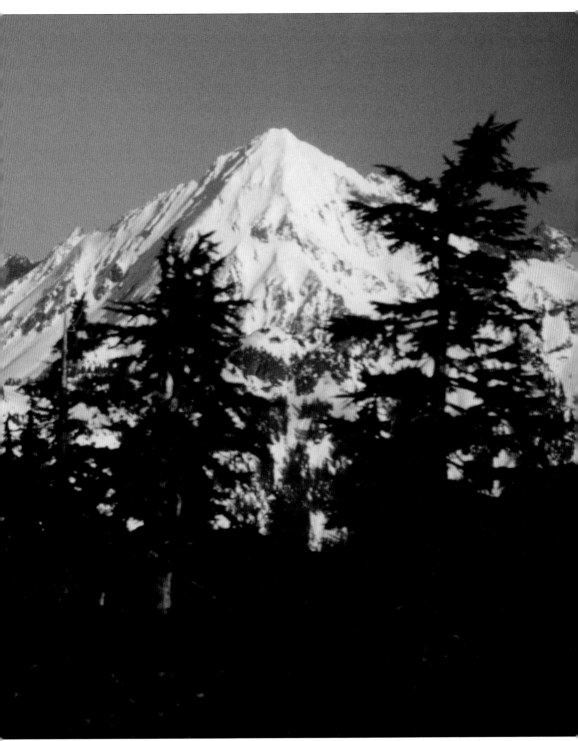

Tom Fyles, Stan Henderson, and R.A. "Gus" Fraser on September 14, 1930. Red Mountain gets its name from the red coloring of it sides, caused by the oxidation of the iron in the country rock.

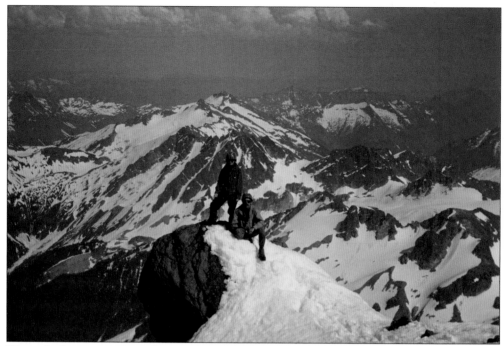

These climbers are enjoying the view from the summit of Glacier Peak, a seldom visited or climbed peak in northern Washington. This volcano has an elevation of 10,528 feet and is the fifth-highest peak in the state of Washington. It is on the southern border of the North Cascades.

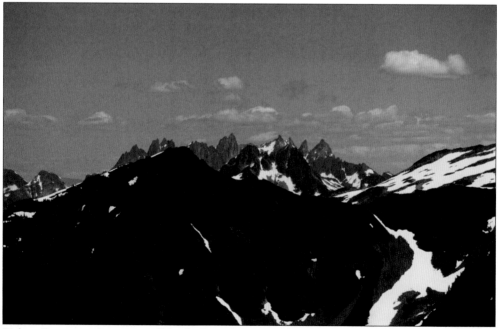

Pickett Range, in the center of North Cascade National Park, is one of the biggest challenges to climbers in Washington State. This mountain range varies between 6,819 feet to 8,311 feet in elevation and covers a span of seven miles. Due to its terrain and location, the Pickett Range has remained the wildest and most unexplored region in the North Cascades.

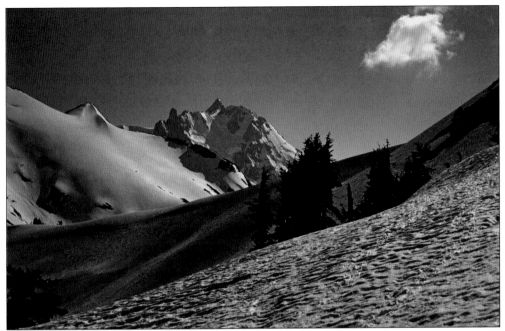

Mount Shuksan is pictured here at an unusual angle. The Nooksack Tower, which is considered one of the most difficult and imposing summits in the Cascade Range, is to the left of the summit block in this photograph, at an elevation of 8,285 feet. The first ascent was made by Fred Beckey and Clifford Schmidtke on July 5, 1946.

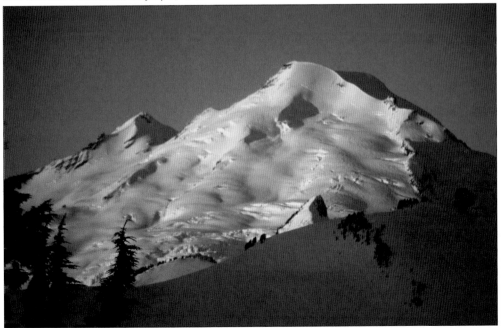

Pictured here is a wintertime view of Mount Baker from the south, with Sherman Peak on the left. This view was taken upon the Park Glacier, which was first climbed by Joe Morovits in 1892. This climb should normally be done prior to August, before the snow is entirely melted from the route. What is commonly called the Cockscomb can be seen on the right ridgeline.

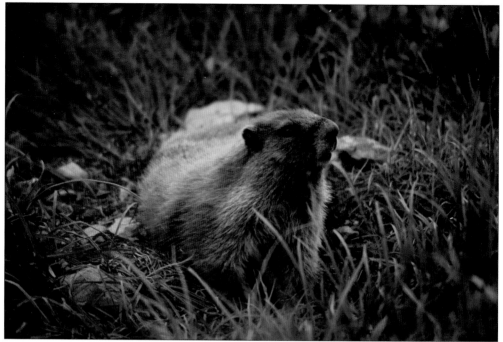

Marmots are large squirrels (sometimes called ground squirrels) of which there are 15 species. They are very often visible on mountain treks on the way to base camp. Their shrill whistle is very distinctive. They do not have a real instinctive fear of people, and climbers may quite often approach them quite closely. They typically live in burrows within rock piles and hibernate there through the winter. They mainly eat grasses, berries, moss roots, flowers, and other greens.

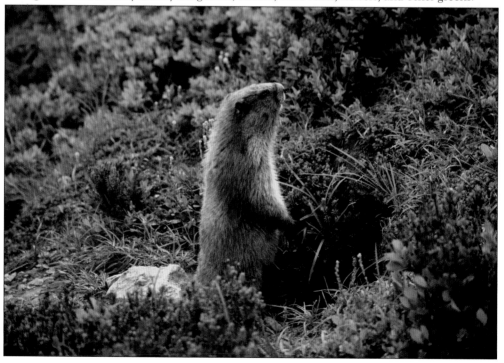

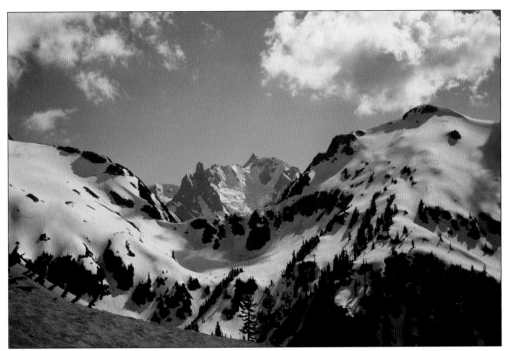

On the way to the Hannegan Pass for a trip up Ruth Mountain, climbers are always treated to outstanding views such as this one of Mount Shuksan situated between two lesser mountains, which are between it and the trail to base camp.

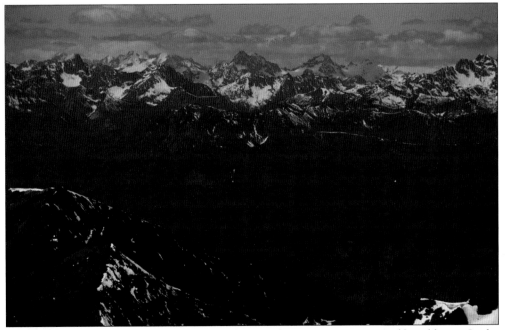

The view from Hannegan Pass over the North Cascades is quite awesome and bewildering. In the North Cascades, there are so many peaks that some of them are unnamed and even unclimbed, even though the significant ones have been documented in both ways. Some aircraft that have been unfortunate to crash within the North Cascades National Park have never been found.

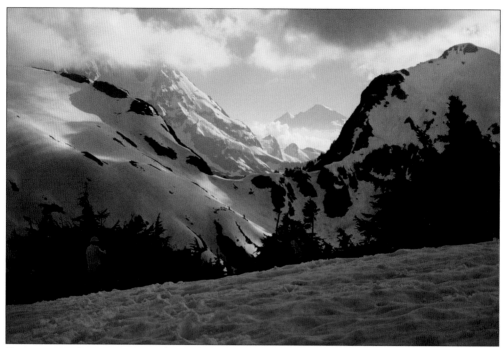

Base camp is being set up in the early evening for the climb of Ruth Mountain the next day. Mount Baker and Mount Shuksan are visible in the background. An early ascent will be planned at first light so that the snow will not be melted by the heat of the afternoon sun.

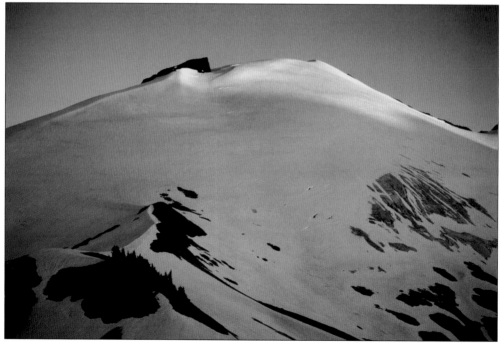

This is the view of Ruth Mountain in the morning as the climb begins. This is not a difficult climb by any standards, although all precautions must be taken as all of the elements of danger are present—crevasses, snow bridges, and hypothermia if a person is injured or seriously delayed.

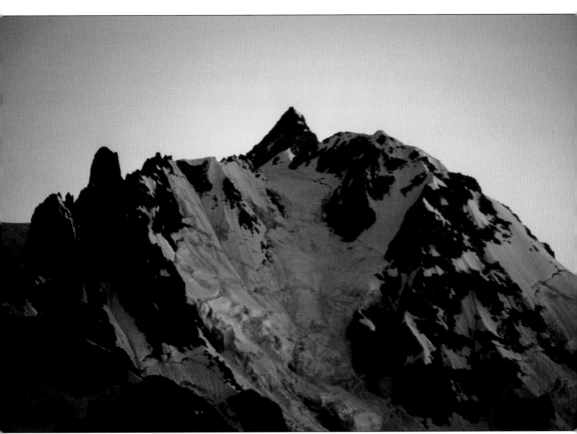

This is a view of Mount Shuksan from the north, as seen from Ruth Mountain. Only a person that has backpacked into the Hannegan Pass area and been up to Ruth Mountain would be able to see it from this angle. The Nooksack Tower, with an elevation of 8,268 feet, is seen to the left of Mount Shuksan's summit. This tower was first ascended by Schmidtke and Beckey in 1946, and it is one of the most imposing and difficult summits in the Cascade Range.

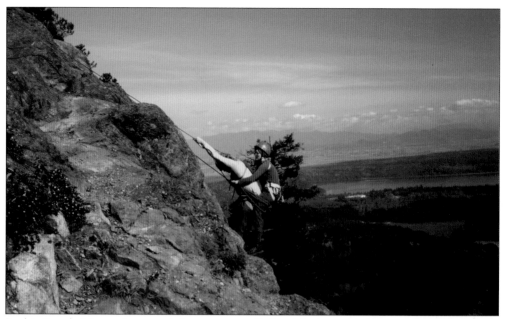

In this Seattle Mountaineers training course, a climber is being carried up a rock cliff on Mount Erie, a longtime training area for climbing and emergency rescue exercises. These skills are taught in the mountaineering courses as safety precautions for climbers. It is to be hoped one will never have to use these measures.

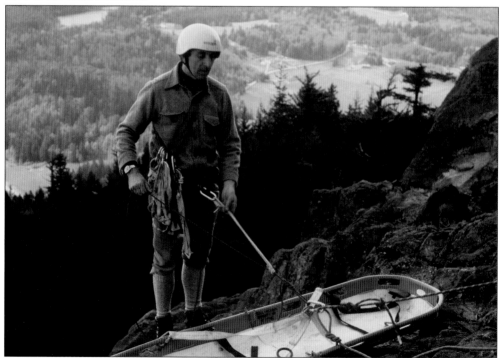

This exercise simulates lowering a person down a rock face with a Stokes basket or emergency litter. The setup for this technique is quite intricate, as the climber, litter, and patient must be carefully belayed either up or down the rock face to be rescued.

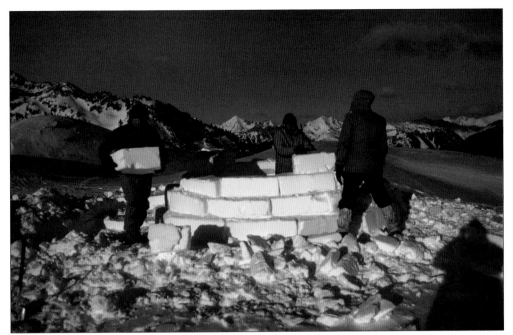

Mountain rescue personnel are making an igloo as part of their rescue training. There are times when a situation may arise necessitating an overnight stay, and tents and other equipment may not be available in the mountains. This is truly a team effort.

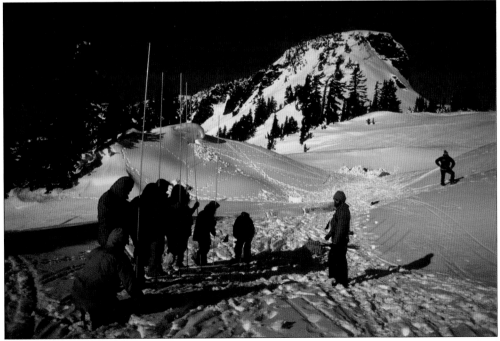

This is an exercise mountain rescue personnel hope they never have to use. They are pictured here with long probes used to search for avalanche victims. By the time the personnel and probes could get to the scene of an event, it is often far too late to save anyone. Nevertheless, this is necessary training.

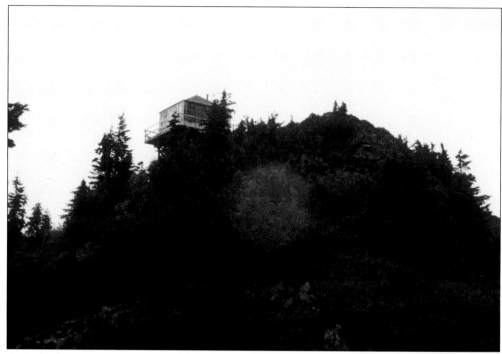

As a climbing party approaches the summit of Winchester Mountain, a lookout is seen ahead. Lookouts are a rare sight in the mountains, as today's satellite imagery, drones, and airplanes have replaced them. A few of them have been preserved by private groups with the help of the Forest Service and other historical organizations.

Winchester Mountain Lookout, at an elevation of 6,521 feet in the North Cascades, was built in 1935 and actually staffed until 1966. In 1982, it was scheduled for demolition, but the Mount Baker Club was able to restore it. It was placed in the National Register of Historic Places on July 14, 1987.

Table Mountain, near Mount Baker, rises above Artist Point and is distinctive due to its unusually flat, table-like top, for which it is named. Not normally considered a climb, its summit offers an unobstructed view of Mount Baker, Mount Shuksan, and the North Cascades National Park.

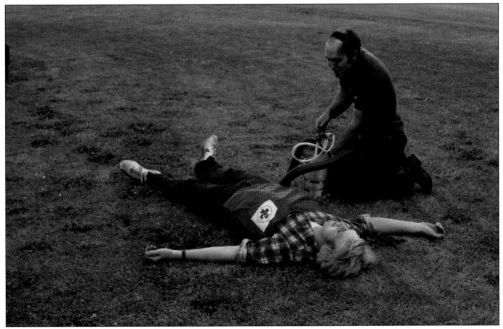

A team of mountain rescue climbers is practicing a lowland rescue using heated water going through tubing held next to a person's chest. This tactic is designed to help alleviate hypothermia (severe cooling), which could happen to a climber who has been exposed to the elements for too long.

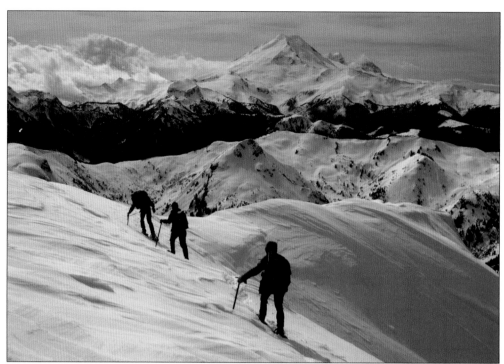

Winter climbers are working their way up towards Tomyhoi Peak on this scenic climb with outstanding views of the North Cascades and Mount Baker area. Tomyhoi has an elevation of 7,435 feet, and it is climbable during most seasons, with the correct equipment. During the winter, proper snow and ice precautions should be taken.

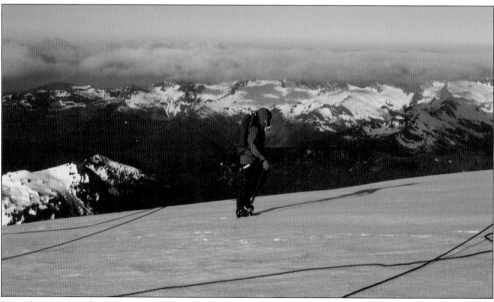

Tomyhoi Peak is less than two miles south of the Canadian border, so a climber has views into the southern mountains of British Columbia. These views are not often seen by travelers up the Baker Highway on the way to ski at Mount Baker. Sometimes this peak is called the best alpine scramble in the North Cascades.

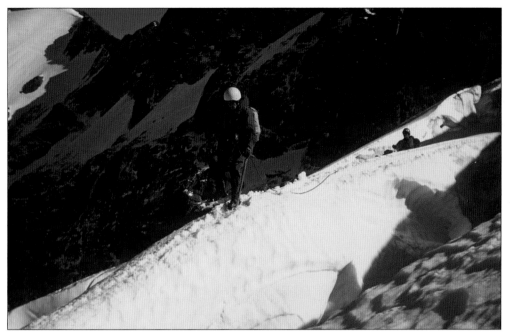

Although Tomyhoi Peak is considered an easy and enjoyable climb, there are parts of the climb that require concentration and winter mountain-climbing skills in season. Here a climber is roped up with a three-party team in order to negotiate a narrow snow ledge and prevent a serious fall onto the exposed rocks below.

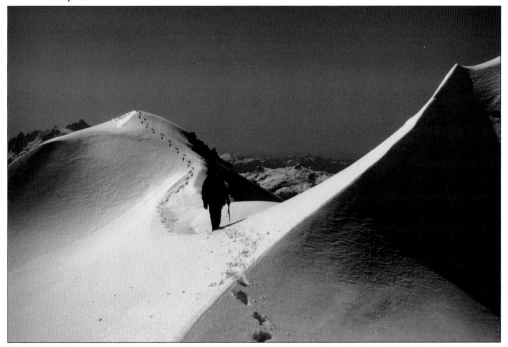

As the going gets easier, it may not be necessary to rope up as the climber did in the above image. Here one of the main concerns is to watch out for snow cornices that may lure a person into thinking his or her position is one of safety just because there appears to be no apparent danger.

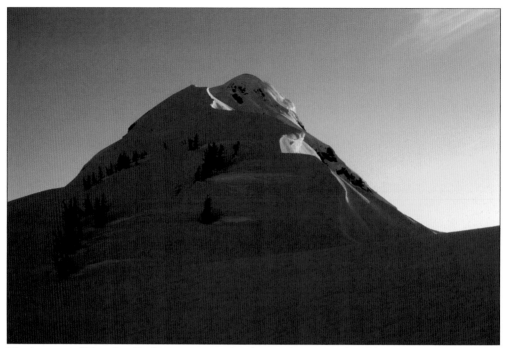

The summit of Tomyhoi Peak is apparent after first scaling an earlier false summit. The caution climbers must take at this point is avoiding getting too close to snow cornices that are caused by the northern winds blowing from the right in this image.

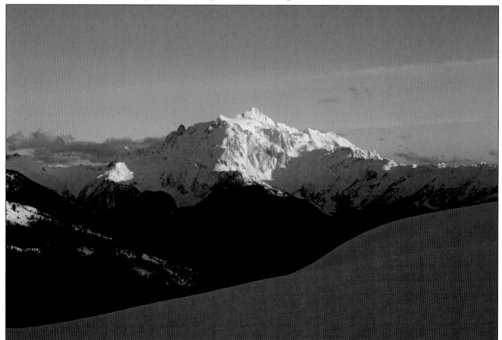

This view of Mount Shuksan is not seen by most people unless they have climbed Tomyhoi Peak. Notice the Nooksack Tower to the left of the ridgeline from the summit. Clear days with views like this, with the sun shining on Mount Shuksan, are quite unusual in this area during the winter.

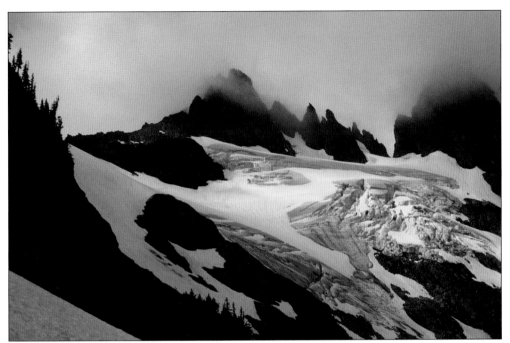

Monte Cristo Peak, at an elevation of 7,136 feet, is another popular peak that is located at the head of Glacier Basin. The first ascent was made by James M. Kyes and W. Zerum in 1923. The first winter ascent was made by Fred Beckey and Mike Borghoff in March 1965.

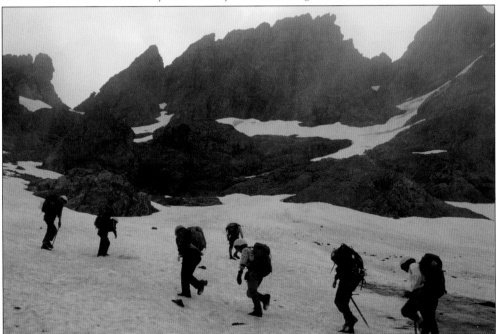

These groups of Seattle Mountaineers are moving up the snowfields towards the summit. This popular climb is featured in their program almost every year, as it offers both snow and rock challenges to the climbers that participate in the climb. All climbers must participate in the basic climbing program to go on this trip.

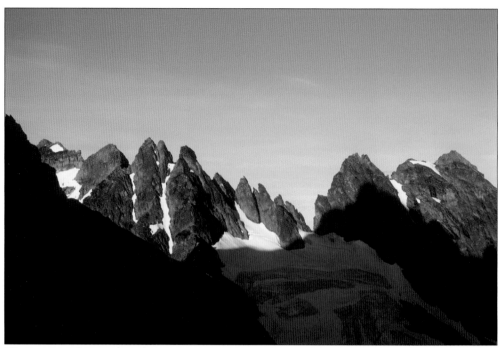

This image, taken in the Monte Cristo area, shows why there are unnamed and unclimbed peaks in Washington. As anyone can see, there are several separate challenges available to the rock climber in just this photograph.

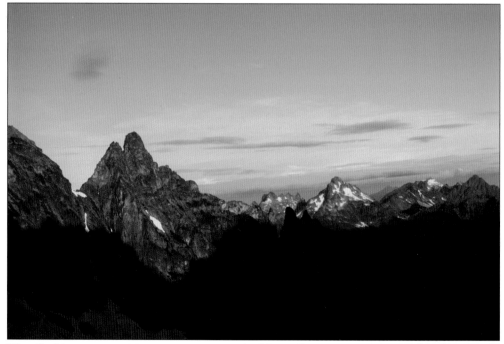

The climbing opportunities are numerous in the Monte Cristo area, as seen in this photograph. Many climbers will travel from afar to set up a base camp and spend as long as time allows, climbing different peaks in the area, with new challenges awaiting them every day.

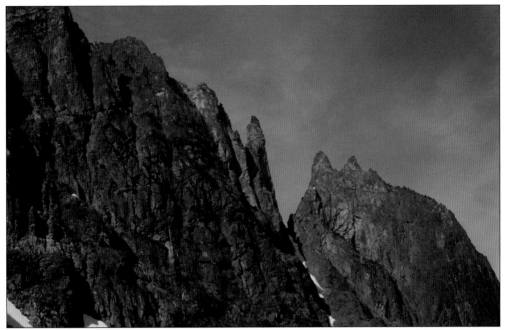

These rock formations offer many challenges to climbers during the summer. Although they are not as stable as the more preferable granite slabs, they present numerous challenges to even the seasoned rock climber. These are not trophy climbs with big names or high elevations but climbs to test a climber's skill, route-finding ability, and strength.

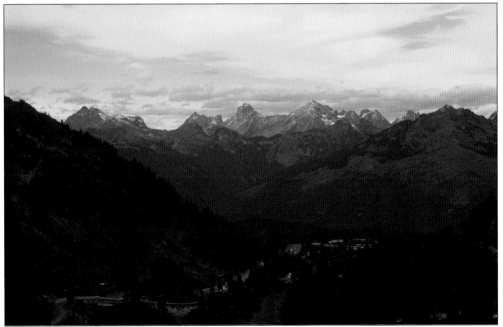

This view from the Monte Cristo region shows peaks near the Canadian border that are significant challenges to mountaineers, not only to get to but also to climb. Seen in the middle background are three significant peaks; from left to right are Canadian Border Peak (British Columbia), American Border Peak, and Larrabee (Red) Peak.

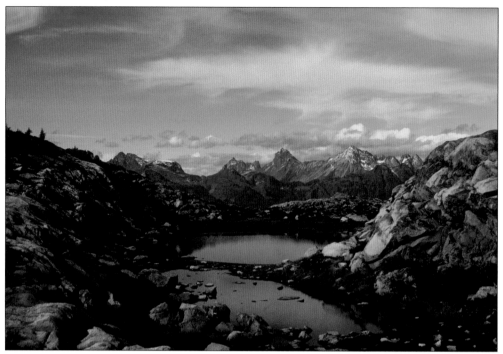

This is a view into the border peaks from above the deserted town of Monte Cristo, of which there are still remnants today. There are many nice trails and areas to explore, including this high alpine lake shown in the foreground, for the person who may not want to climb or climbers who want to take advantage of an off day.

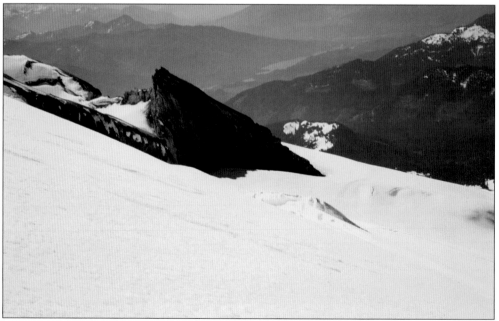

Lincoln Peak is shown as a climber sees it on the way up Mount Banker at an elevation of 9,080 feet. Fred Beckey, Wesley Grande, John Rupley, and Herb Staley are credited for making the first ascent of this lava outcropping on the southwest facet of Mount Baker on July 22, 1956.

*Three*

# WESTERN WASHINGTON/ MOUNT OLYMPUS AREA

The Olympic National Park is the most visited national park in Washington, even beating out Mount Rainier in number of visitors each year. There are three reasons for this: one is the winter accessibility to Olympic National Park, another is the sheer size of the park that is surrounded by a paved road, and the last is that it includes 60 miles of Pacific Ocean beach.

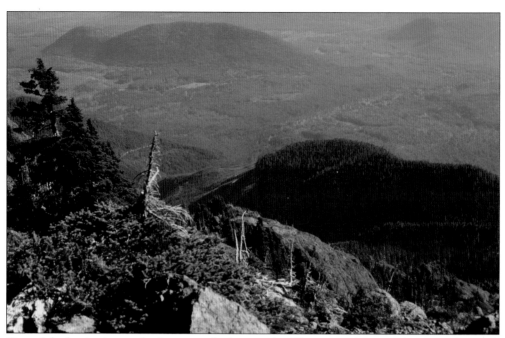

One of the beginning peaks for many climbers in the Olympics is Mount Elinor, on the south end of the park at an elevation of 5,944 feet, which keeps it accessible most seasons of the year. It is readily accessible by road and offers outstanding views in all directions once the summit is achieved. This is a view of the terrain about halfway to the summit.

This image shows what the summit of Mount Elinor looks on the approach to the top. Along the well defined path on this climb, one will very likely encounter mountain goats and deer, not to mention a lot of large flies that will bite in the summer season.

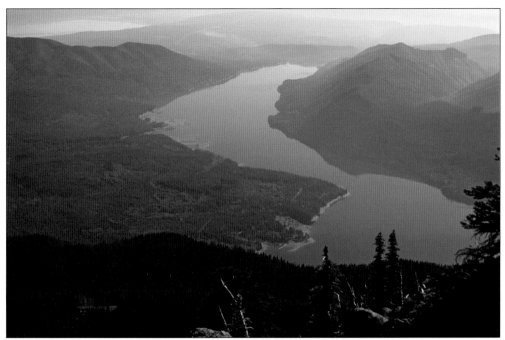

Upon reaching the summit of Mount Elinor, the views are outstanding on a clear day. This view is to the south and shows Lake Cushman and the surrounding area. Lake Cushman is over eight miles long and covers over 4,000 acres. It is on the north fork of the Skokomish River in Mason County, and Cushman Dam No. 1 provides power to the Tacoma Power System.

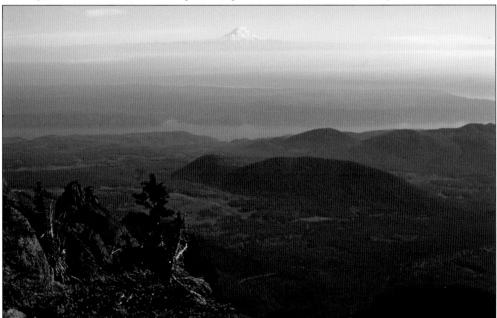

Mount Rainier is visible looking to the southeast from the summit of Mount Elinor on a clear day. Quite often the experience of climbing a peak such as Mount Elinor, which is normally accessible in the summer by a healthy person, will inspire one to further heights in mountaineering. On the other hand, sometimes it has the opposite effect if the person did not enjoy the trip.

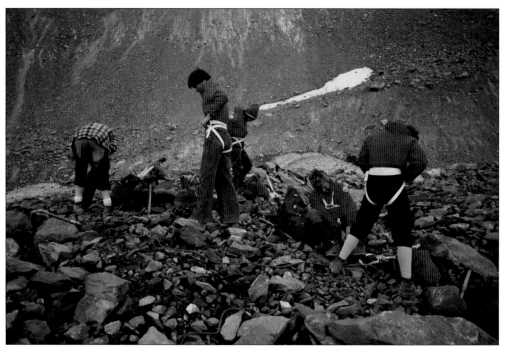

If a person chooses to climb Mount Olympus, it is an 18-mile trip to base camp near the Blue Glacier. The group would get up at first light or earlier to get dressed and put on their climbing gear on the glacial moraine, such as these climbers are doing, to begin their trip.

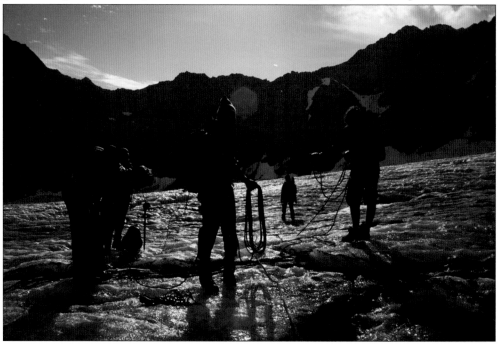

It is often dark when climbers first step onto the glacier, as that is the very best time to cross, before the ice has a chance to soften up or even melt, making it more dangerous to traverse. Notice the coiled rope in the climber's hand that indicates he has not started to cross the glacier yet.

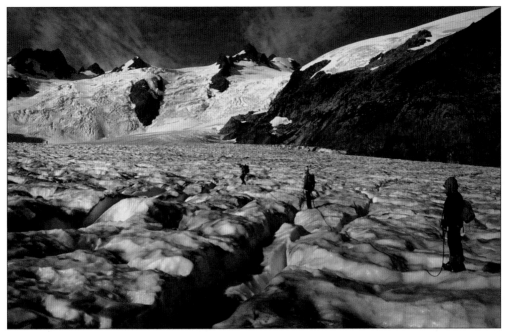

When the group is all tied up and ready to go, the leader of each rope team will carefully move out onto the glacier, and the other members of the team will be ready to retrieve him or her should there be an accident or a slip. This team is showing excellent glacier technique by keeping their rope stretched out while crossing.

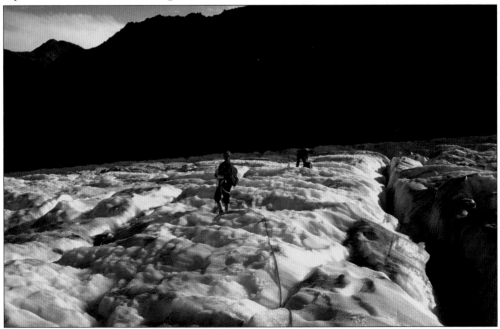

It is very easy to slip on the ice unless a climber is wearing adequate ice crampons and carrying an ice axe to prevent falling into a crevasse like the one shown to the right of this climber on the Moon Glacier on the way up to Mount Olympus. There is no telling how deep the crevasses are, and to fall into one untethered would certainly be fatal.

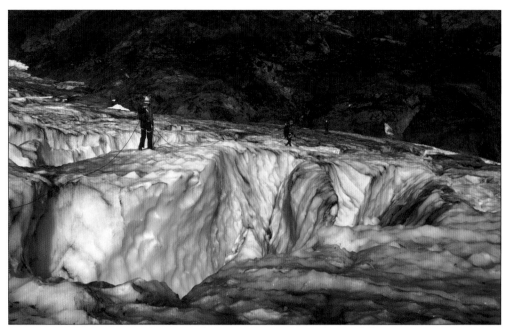

Moving across glaciers, as shown in these two images, is a slow and dangerous process, as one never knows the strength or the thickness of the ice below. In addition to the fragility of the ice, navigation is an important aspect of getting across the glacier. The most direct route may not always be the safest. In the bottom image, the leader of this rope team is almost across the glacier and is about to give a sigh of relief, as leading a climbing team across a glacier is a dangerous and nerve-wracking endeavor. Not all climbers are willing to take on this responsibility, due to its hazards.

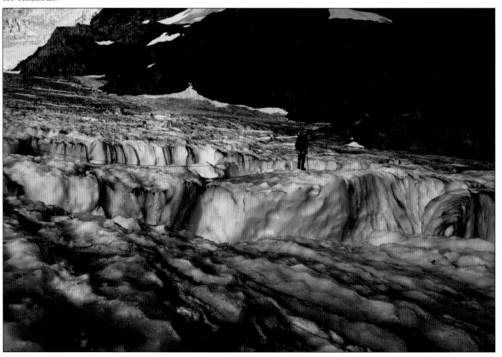

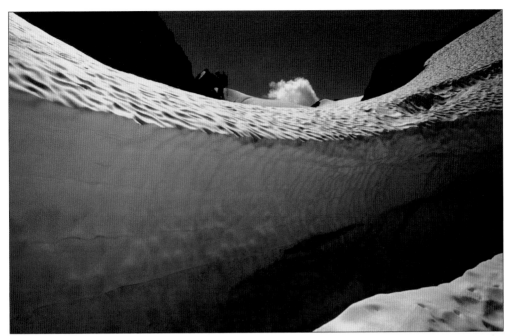

After the glacier is crossed, there are always other things to be taken into consideration for the safety of the climbing party. Shown above is a couloir, which is a deep gap between the rock and a snowfield. These are always to be taken seriously, as they are easy to fall into and hard to get out of without any assistance.

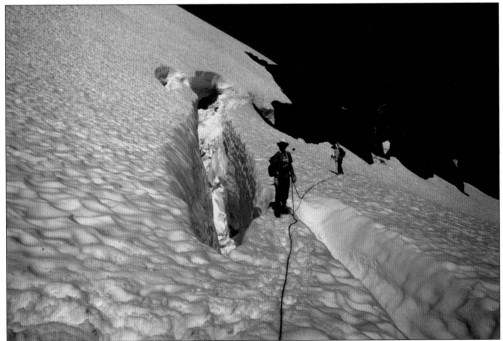

Crevasses are something climbers must always be on the lookout for while traveling on snow. Keeping roped up on snowfields after crossing a glacier is sensible, as the snow is not always evenly dispersed in the mountains like it may be on level ground at lower elevations.

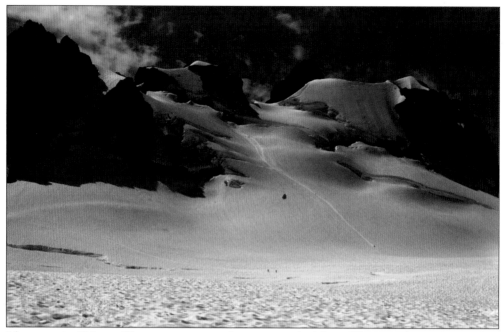

The summit of Mount Olympus is in view after crossing the Moon Glacier. What appears at first to be tracks coming directly down from a snow valley near the summit is actually a snowball that has rolled down the hill. This indicates soft snow, and taking a route around the area would be best to avoid avalanches.

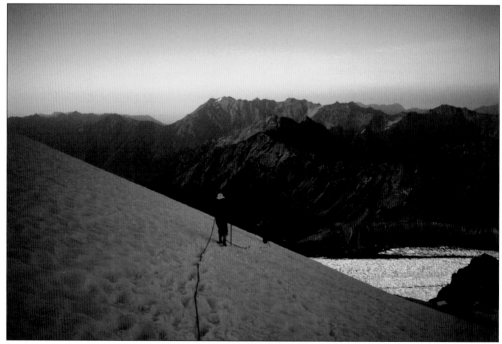

Standing on the snow on the way up to Mount Olympus, Moon Glacier seems a long way off and far below. Sometimes it is hard to imagine how far one has climbed in a few short hours when the focus remains on the climbing and scenic aspects of the trip.

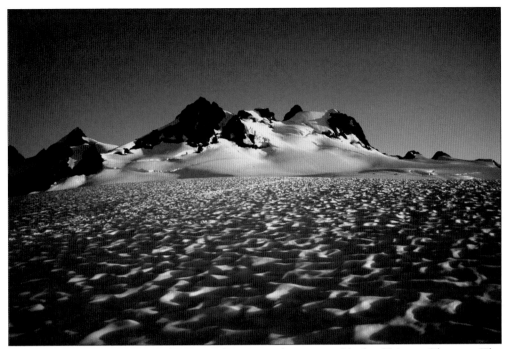

Suncups are very much in evidence on the way to the summit block of Mount Olympus. The route is now quite apparent, and the end appears to be in sight. At this time of the day, the snow is beginning to become soft and is somewhat harder to travel in as a result.

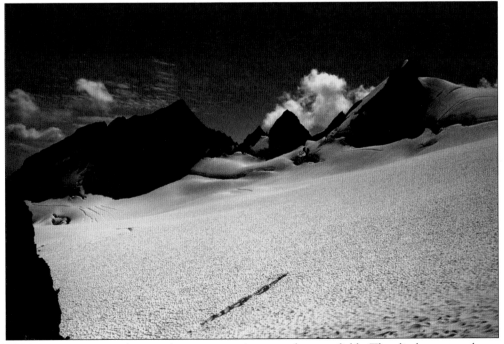

The summit is getting closer as the ascent continues up the snowfields. The climbers must always be wary of the subtle crevasses in the snowfields on the way to the top. Falling into small fissures has been fatal to more than one climber through the years if they could not be rescued.

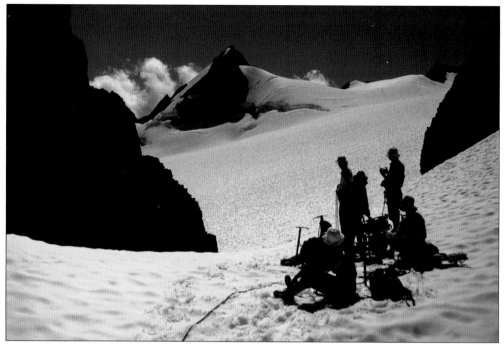

It is time for a rest as these weary climbers reach the final approach to the summit block of Mount Olympus. At this point, what appears to be the summit is really a false summit that is fairly close to the final approach. Some rock climbing is necessary beyond what is presently seen.

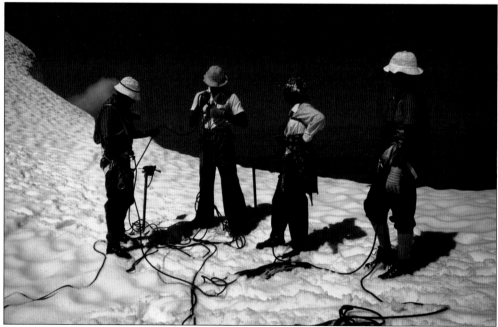

Climbers are stopping for a break, adjusting their climbing gear, and doing a little route finding for the final approach to the summit. Their backpacks are off, hard hats removed, and they are safely away from most dangers of the climb, except sunburn, as one can determine from the hats they are wearing.

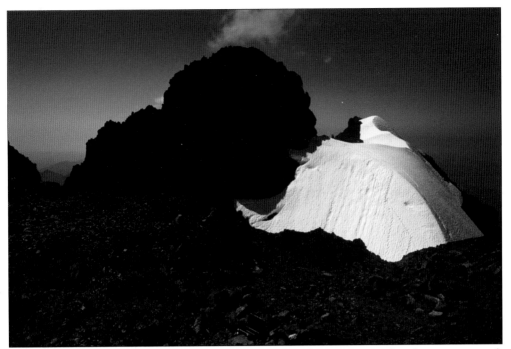

The final approach to Mount Olympus is now in view, and it is apparent that there is some rock scrambling to be done ahead. This will require a much different skill set than what has been used on the rest of the climb, which was on a glacier or snow.

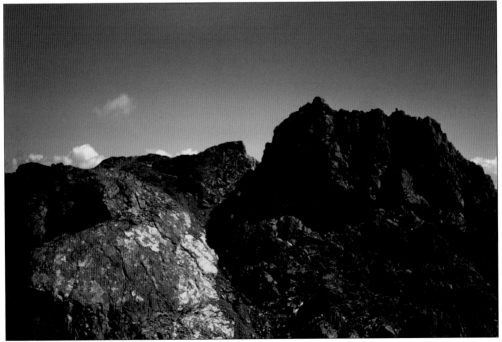

The final summit block of Mount Olympus stands out now, and the route is easily determined to be around the left side of the prominence, as the snow on the other side may be somewhat impassable and difficult to navigate. The weather is perfect, and the end is in sight.

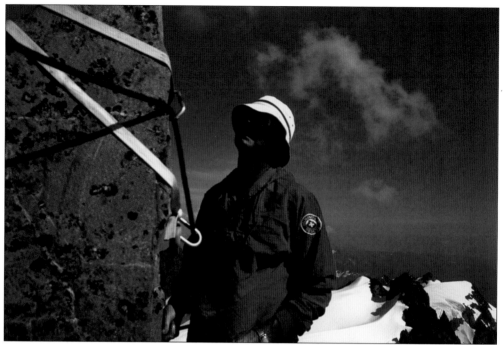

This climber, who is belaying another climber from below, is watching intently in case the leader on this rope takes a fall. Notice that this belayer is wearing a mountain rescue patch. It is always comforting to other climbers to have these highly qualified climbers on a trip with them.

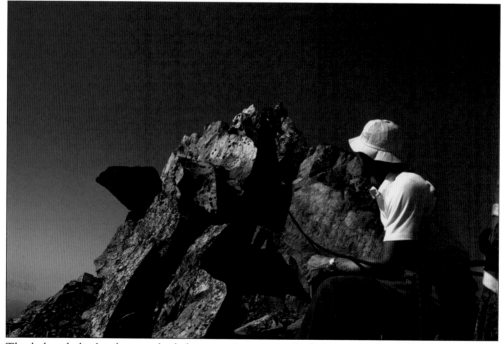

The belayed climber has reached the summit, so now the belayer may begin his ascent to the top. The climber has elected to not wear his hard hat at this point since the chance of any rock fall from above is very unlikely.

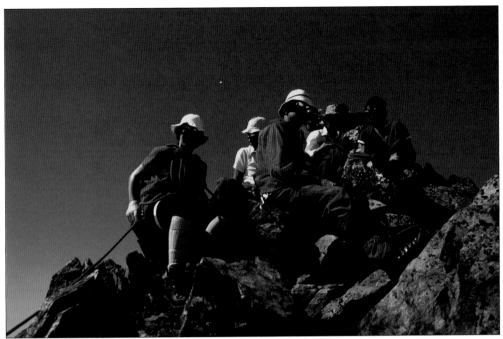

All climbers are safely on the summit now and taking a well deserved break, enjoying the views, having lunch, visiting, and planning the trip down. Only half of the trip has been completed at this point. It is well known in the climbing community that the descent down from any summit is more dangerous that the ascent. The reasons for this are numerous: the climbers are tired, sometimes in a hurry to return home, and the snow is a lot softer and more likely to give in than on the ascent, which is normally done at a much lower temperature.

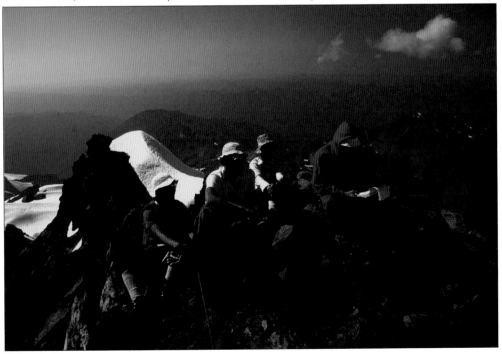

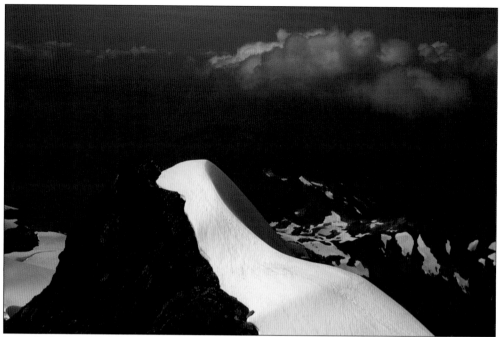

Just a little beyond the summit of Mount Olympus lies what appears to be an interesting walk and an additional challenge for the climbers. Even though this additional trip looks interesting, it is in the climbers' best interest to enjoy the views from where they are and prepare for the return trip.

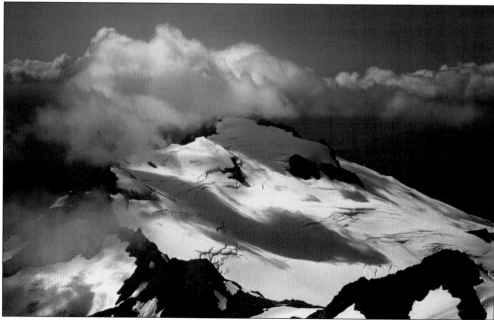

Well beyond the tempting short trip above lie many additional peaks to the west that would be interesting to climb another day. Already, additional plans for the next climbing trip to the Olympic National Park may be being made, as there are still many more peaks to be climbed in the Olympics.

# *Four*

# EASTERN WASHINGTON/ MOUNT STEWART AREA

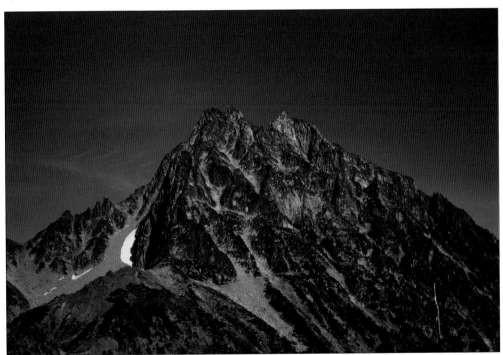

Mount Stewart, in eastern Washington, has many faces and routes to the summit. Some of them are quite easy and can be accomplished by a good rock scrambler without technical rock climbing skills, and other routes require advanced rock-climbing techniques that necessitate plenty of training and skill. This is a typical summer image of Mount Stewart in the peak of the climbing season. Mount Stewart is the most visible, and in some ways, the most interesting climb in eastern Washington. The many rock pitches on the Icicle River near Leavenworth, Washington, and other areas are not included in this book.

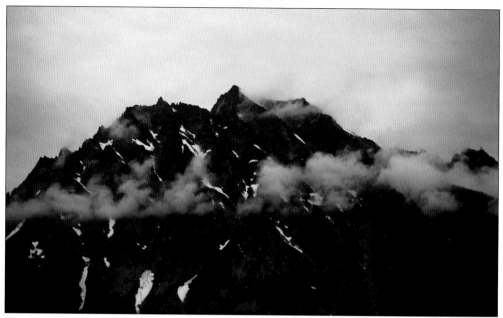

Because of the relatively high elevation of Mount Stewart, the type of climbing will vary significantly in any given season or on any particular day during volatile weather changes. These two photographs show what a climber might expect in the winter. Also, even though Mount Stewart is in eastern Washington, clouds, fog and even rain can be expected, sometimes quite by surprise during a climb at this elevation. There is no reason for climbers to alter carrying the "Ten Essentials" during a climb of Mount Stewart just because the last weather report that was heard was favorable for a climb.

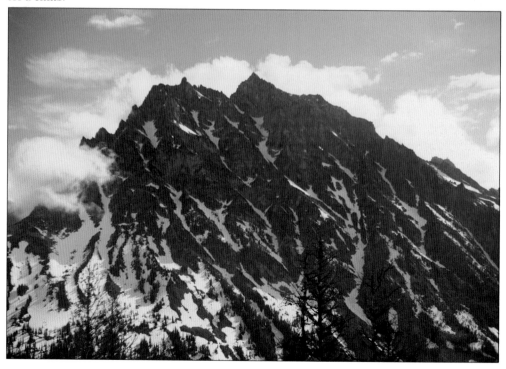

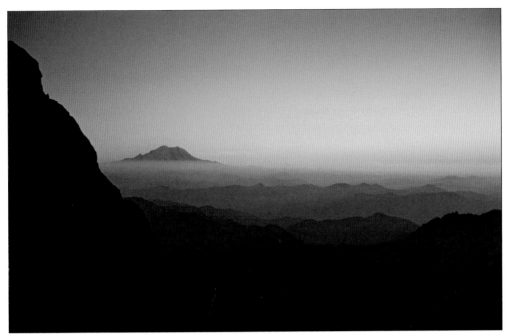

Even though sleeping may not be too comfortable, a climber could be rewarded with a view such as this of Mount Rainier and other Cascade mountains to the south as the sun rises when he or she awakens. For the more technical west ridge route climb of Mount Stewart, it is a two-day climb involving an overnight bivouac.

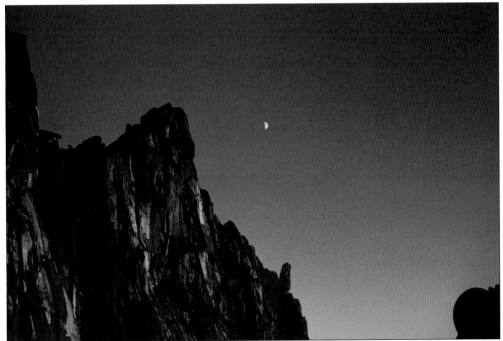

The early morning light is hitting the granite walls of Mount Stewart in this early morning photograph during the beginning of the climb. The moon can still be seen just to the right of the summit. These types of views are changing during the climb to the summit.

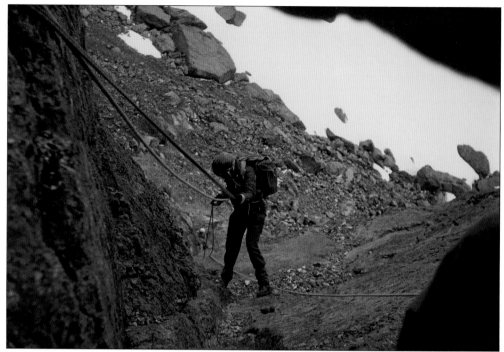

Here a climber is working up the way of a steep face on Mount Stewart. Almost all of this climb is roped and belayed on the upper parts of the climb. There is no solo free climbing on this part of the climb, as the exposure to a bad fall is just too chancy.

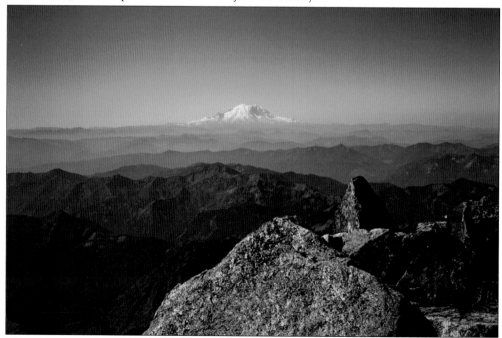

This is a view of the summit of Mount Stewart looking southwest to the summit of Mount Rainier with much of the Cascade Range in view between. The distance between Mount Stewart and Mount Rainier is approximately 70 miles.

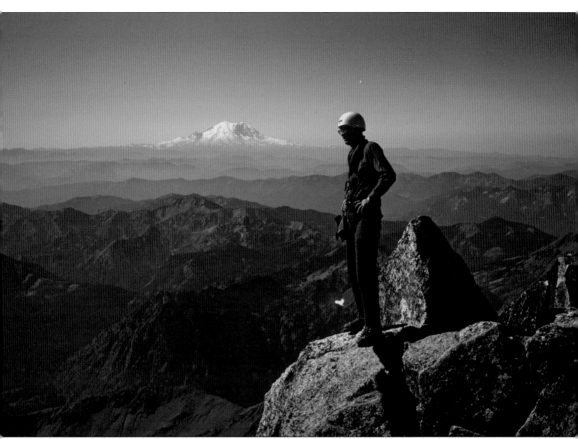

Earl Willey, climb leader of this intermediate trip for the Seattle Mountaineers, stands on the summit of Mount Stewart after leading this successful climb for his climbing party. This trip was up the west ridge of Mount Stewart, considered one of the more advanced climbs on this peak. Willey was a Seattle Mountaineer instructor and climb leader for many years. His leadership in the mountains was appreciated by all who were lucky enough to climb with him. Much of his climbing strength in his legs came from many years of climbing electrical poles for Seattle City Light as an electrician.

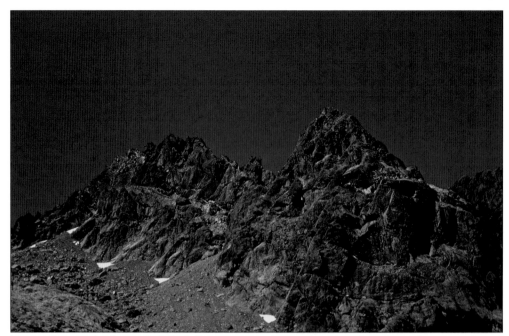

Mount Stewart displays a slightly different personality in this view that shows the west ridge off to the right. This image was taken in midsummer when there were no snow challenges being offered at the lower levels before climbing onto the granite rock surfaces, which are very good for climbing.

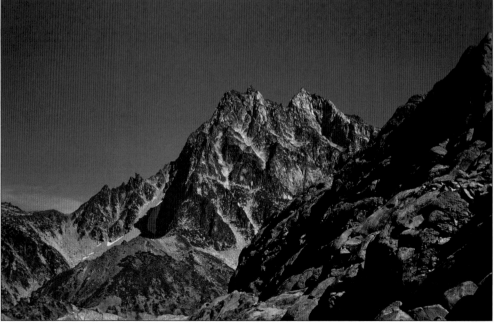

This view of Mount Stewart is looking directly at the west ridge, which is a significant climbing challenge. It is considered one of the classic Mountaineers rock climbs, and many students climb this route to complete the intermediate climbing program. The exposure is significant on this route near the summit.

*Five*

# SOUTHERN WASHINGTON/ MOUNT RAINIER AREA

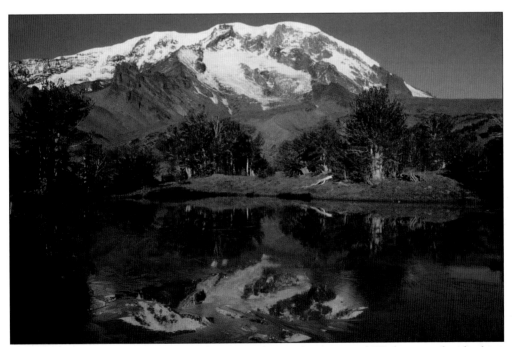

There are three distinct peaks that dominate the southern area of Washington for climbing enthusiasts. They are Mount Rainier, Mount St. Helens, and Mount Adams. Along with these peaks are many others that are excellent challenges and offer wonderful views of the area. To name a few are the Tatoosh Range, Little Tahoma, and the Goat Rocks Wilderness area, which includes various peaks ranging from 3,000 feet up to Gilbert Peak, which is over 8,200 feet in elevation.

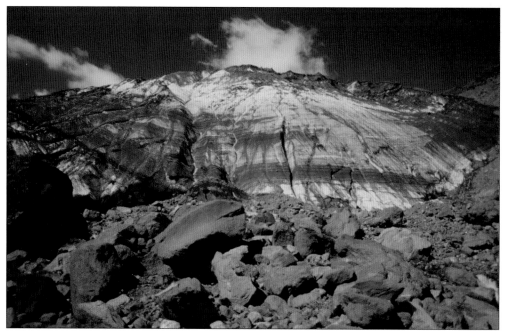

These images show the Nisqually Glacier in two distinct time periods. The upper one is a current image, and the lower one shows how people used to walk into the ice caves, as they were then known, about 50 years ago. Global warming has significantly reduced the glaciers in Washington and worldwide in recent years. This trend is likely to continue for many years to come. This glacier is the source of the Nisqually River, which flows into Puget Sound near Olympia at the Nisqually delta.

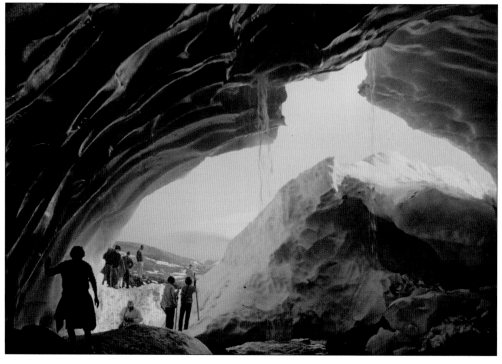

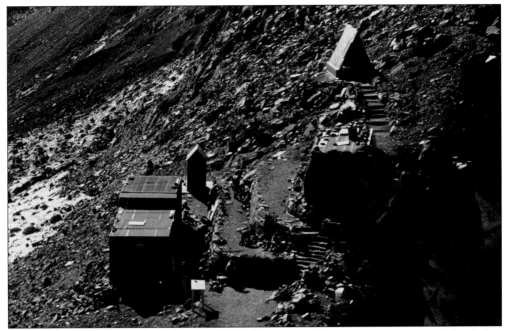

Camp Muir, at the 10,000-foot-level of Mount Rainier, is the most common overnight shelter for climbers who are attempting the summit. The typical time to start the summit attempt is at midnight or 1:00 a.m. Seen here is the public shelter and cooking and guide huts, which are used to store emergency supplies for the mountain.

Climbers are approaching Camp Muir, which is a public shelter used on a first-come first-served basis for anyone who would like to use it. It is also used as a safety zone during inclement weather that threatens climbers who are in the area. It is the normal overnight camp spot for climbers before leaving for the summit early the next morning.

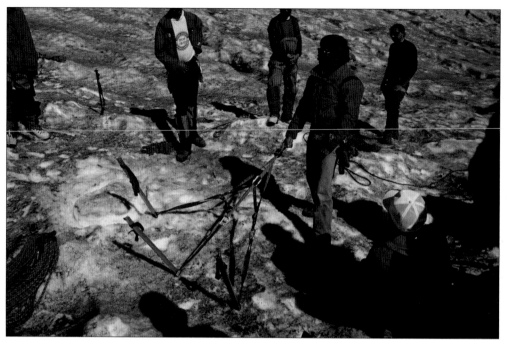

A mountain guide is demonstrating crevasse rescue techniques a day or two before the group summit attempt. Quite often, climbing schools are conducted for two days at lower elevations, and a few days of more intensive training are conducted at higher levels. This also allows for acclimation prior to the summit climb.

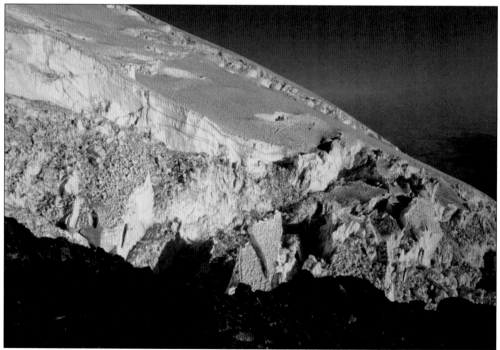

Icefalls and crevasses are the dangers of climbing up the Emmons Glacier after negotiating around Gibraltar Rock. This image was taken at an elevation of 12,000 feet, and the going is very slow.

Little Tahoma is seen from the Ingraham Glacier on the way up Mount Rainier. The summit of Little Tahoma is at 11,117 feet, and it is a challenging rock climb for mountaineers. The first ascent is credited to J.B. Flett and H.H. Garrison in 1895. This peak is seen from Seattle, Washington, and some of the areas around Puget Sound on the east side as part of Mount Rainier.

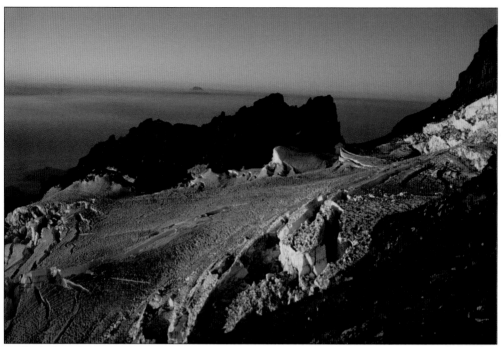

Cathedral Rocks are seen from Ingraham Glacier on the way up Mount Rainier. On the right is Liberty Rock, and Cadaver Gap (named by mountain rescue groups) is seen in the middle. Above Cathedral Rocks, Mount Adams is pictured here in the early morning.

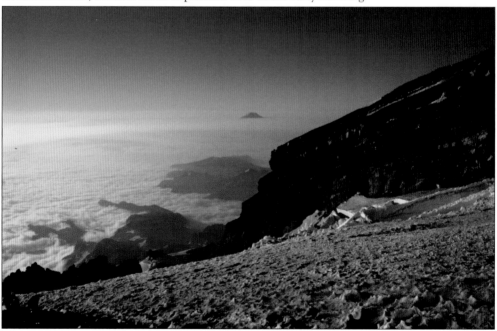

Gibraltar Rock is one of Mount Rainier's most massive rock outcroppings. Its peak is at 12,600 feet and divides the Nisqually and Ingraham Glaciers. There is rock fall danger in passing Gibraltar Rock, and a large section fell off in 1936 and blocked the climbing route until 1948. Mount Adams is seen in the distance.

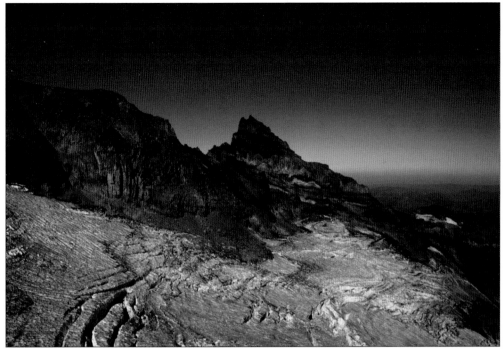

Little Tahoma is a remnant of what was a larger volcano and sits between the Ingraham and Emmons Glaciers. There is always a potentially serious rock fall hazard on this peak, so climbers must be very cautious while making the ascent.

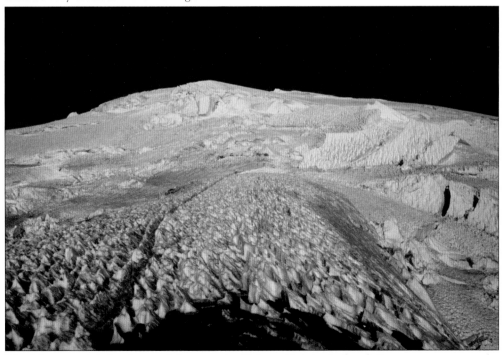

The false summit is in view, and the summit of Mount Rainier is ahead. Suncups are seen on the way up to the summit from the previous day's exposure to the eastern and southern sun rays.

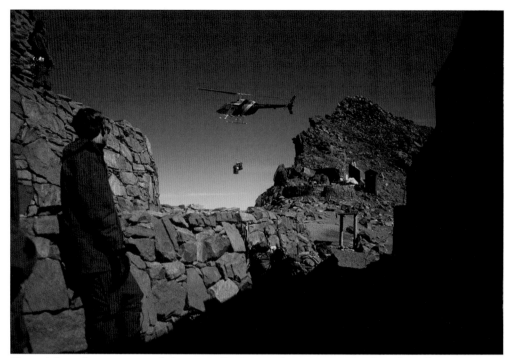

Camp Muir often gets crowded, especially during the summer months when there are many guided climbs with cooking staff and guides in support of climbers, and helicopters are regularly used to transport supplies to the guide huts. Camp Muir, at an elevation of 10,000 feet, is the normal maximum altitude for most commercial helicopters. If rescues or other needs determine that a helicopter go higher up the mountain, even to the summit, it would come from one of the nearby military bases in the area.

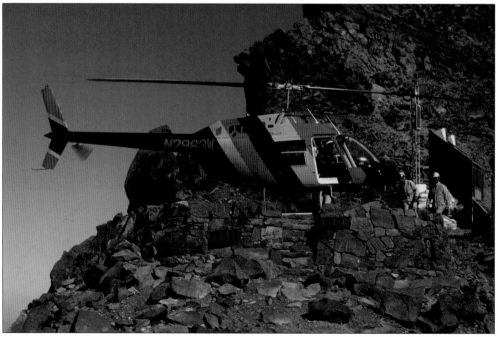

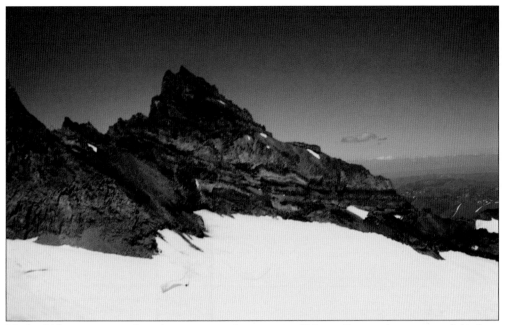

Mount Tahoma is viewed on the way up to the summit of Mount Rainier by a group of climbers ascending the Ingraham Glacier during the earlier spring months while the Emmons Glacier is covered with snow, concealing the dangerous crevasses that lurk treacherously just below the snow's surface.

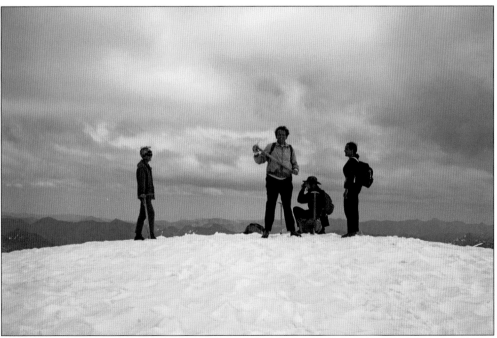

These hikers are on Burroughs Mountain, which is an excellent introductory trip for any aspiring mountaineer to get the feel of the mountains. This trip, if taken before winter sets in or after the snow melts in spring, lets potential climbers learn mountain skills at a low level without encountering serious danger.

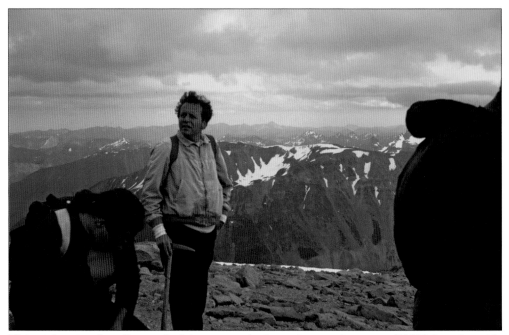

This is the view from Burroughs Mountain, which reaches an elevation of 7,828 feet alongside Mount Rainier. The views afforded from this relatively easy hike are enough to inspire almost any beginning hiker to further exploration of the surrounding mountain area.

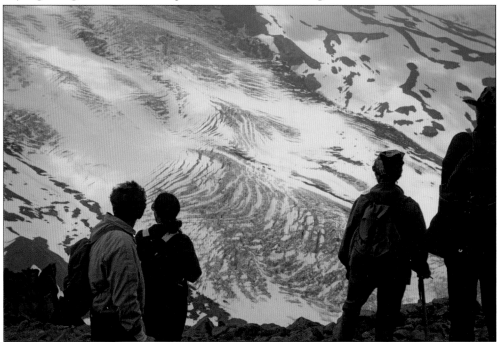

From what is called the "Third Burroughs," these hikers are looking down upon the Winthrop Glacier, which is a large glacier on the northeastern side of Mount Rainier. This large glacier covers about 3.5 miles and has a volume of approximately 18.5 billion cubic feet. It connects at a higher level to the Emmons Glacier at Steamboat Prow.

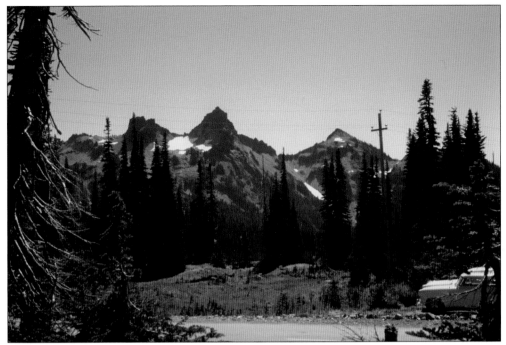

The Tatoosh Range is another excellent area for the beginning or aspiring climber to learn the ropes. This range of mountains, directly south of Mount Rainier, runs from east to west, and varies in elevation from 5,000 feet to just short of 7,000 feet. There are a total of 13 peaks in this range to challenge beginning mountaineers.

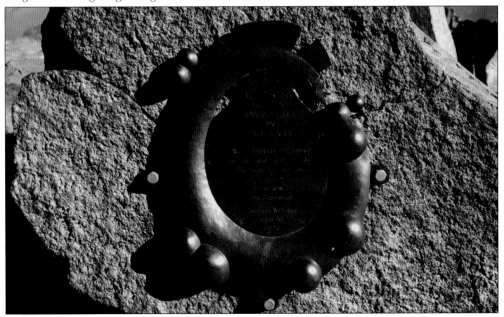

As a reminder that the mountains are a dangerous place, even for the most skilled of climbers, this plaque at Camp Muir memorializes the deaths of Willi Unsoeld, one of America's most famous and beloved mountaineers, and Janie Diepenbrock, a 21-year-old student of the outdoors, who perished on the upper Cowlitz Glacier on March 4, 1979.

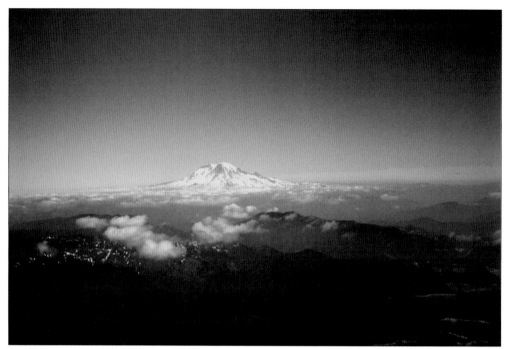

A climbing team working its way up the Shoestring Glacier on Mount St. Helens prior to 1980 would see this view of Mount Rainier with Sprit Lake below. Views like this are no longer available since the eruption of Mount St. Helens in 1980. Early explorers coming down the Columbia River often confused Mount St. Helens, Mount Adams, and Mount Rainier, all of which were glaciated peaks at the time. In the lower photograph, Oregon's Mount Hood is seen to the south. Mount Adams is often the forgotten peak of southern Washington, as it has no tourist facilities and can only be approached on an unpaved road.

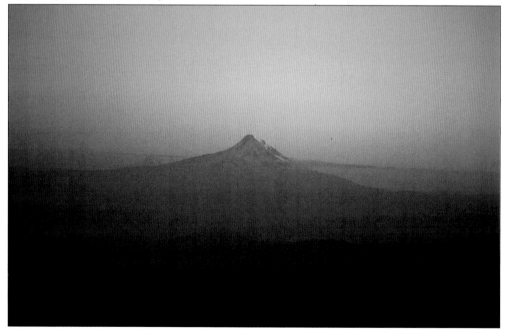

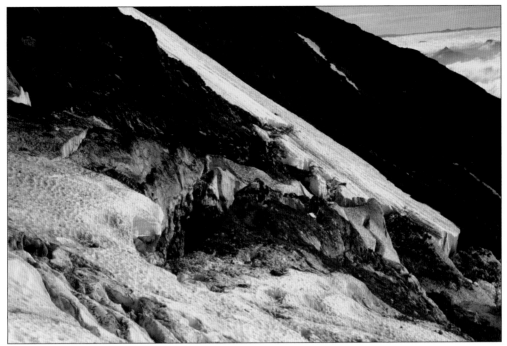

As climbers ascended the Shoestring Glacier, more crevasses and navigating challenges were in store for the duration of the climb. Shoestring Glacier no longer exists on Mount St. Helens due to the 1980 eruption. The black seen on the glaciers is ground-up lava and will become glacial moraine.

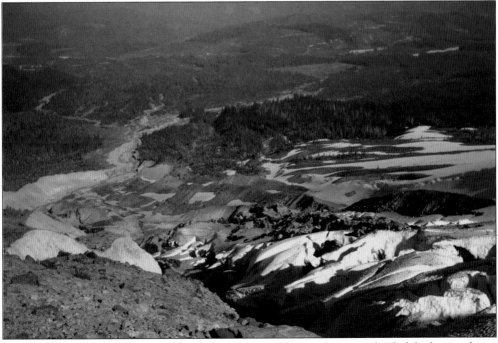

Looking down from a higher level on the Shoestring Glacier, one gets the feel for how a glacier is formed and how powerful they can be, cutting into the mountainside and causing the ground to move as the heavier ice above presses downward on the earth to the levels below.

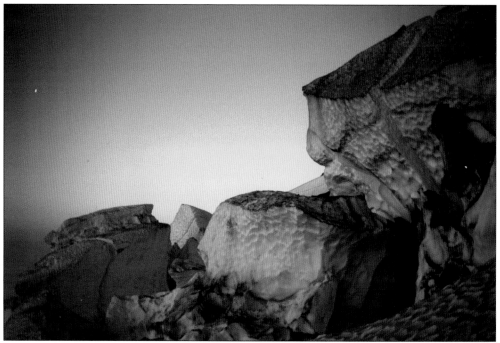

These large blocks of ice are somewhat unnerving to walk by as one realizes they may come crashing down at any time, particularly if the temperature is warming. There is no way in the world to know when and if they will move. Most all mountaineers realize that the mountain may move at any time.

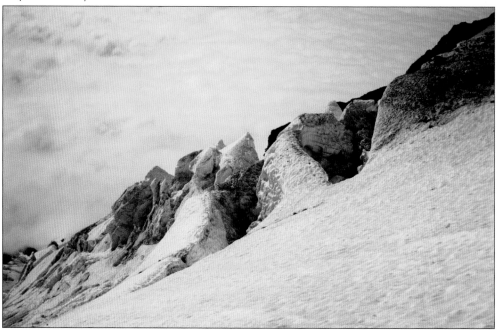

The constant motion of the glacier is apparent in the shape and design of the ice as it freezes and thaws and is pushed down the mountain by the sheer weight of the ice and snow. All this weight digs into the earth and causes what is called glacial moraine.

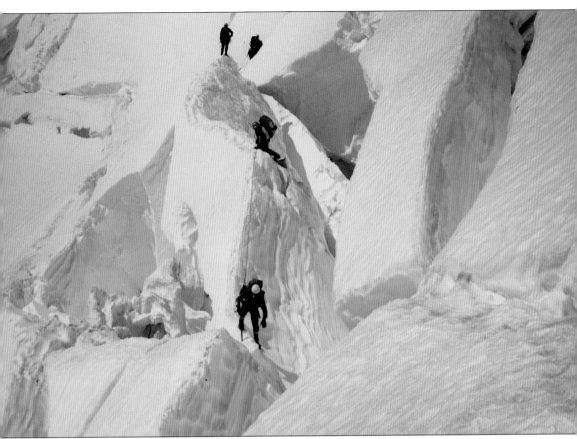

Navigating through and around the crevasses and icefalls of the glacier is always tricky and quite dangerous for any group. It is always important to climb early in the morning, before these giant ice blocks start to melt and move later on in the day. This is what climbers would call the crux of the climb.

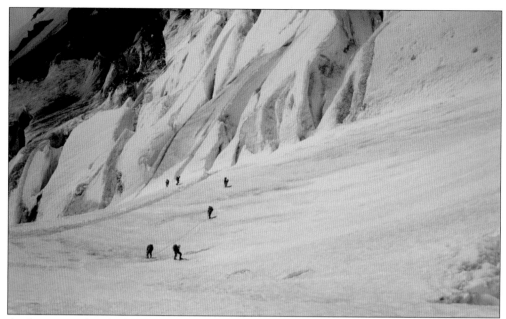

At this point, the climbing team is past the glacier and heading up towards the summit, which had an elevation of 9,677 feet. The first recorded ascent of Mount St. Helens was on August 27, 1853, by T.J. Dryer, J. Wilson, Smith, and Drew. The climbers pictured here have passed the crux of the climb.

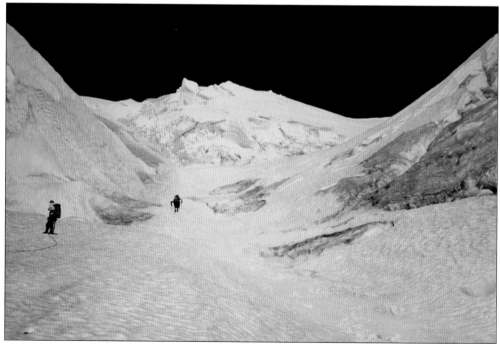

The summit appears ahead, but this is what is called a false summit in climbing. The climbers have navigated the challenging part of Shoestring Glacier, are now at an elevation of about 9,000 feet, and have about an hour of climbing left before reaching the real summit. When this climb was done, there was the smell of sulfur in the air at this level.

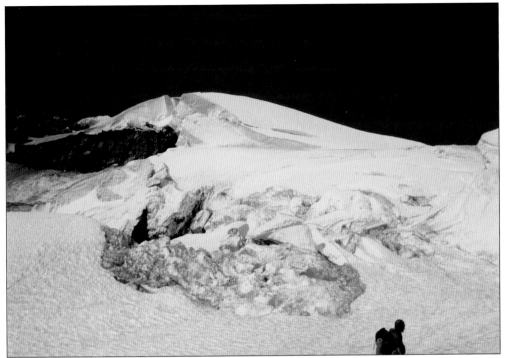

The final approach is still challenging, but the climbing team will navigate to the right-hand side of the glacier and icefall, where the traveling is much safer and more straightforward. What appears to be the peak at this point is still not the actual summit of Mount St. Helens.

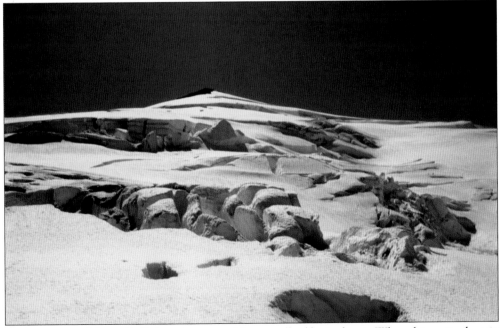

At this point on Mount St. Helens, it was possible to smell sulfur in the air. When this particular trip was taken, there was no eminent threat of an explosion, and it was the furthest thing from anyone's mind. It was always in the back of climbers' minds that maybe someday it would erupt.

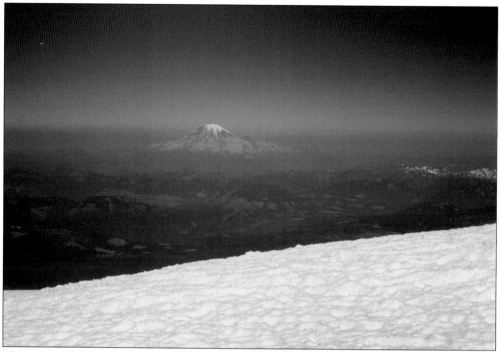

This view of Mount Rainier was taken from the higher elevations of Mount St. Helens to the south. Seattle, Washington, would be to the north. The peak on the right side of the mountain is Mount Tahoma, which is often seen from Seattle on a clear day appearing on the left or eastern side of the mountain.

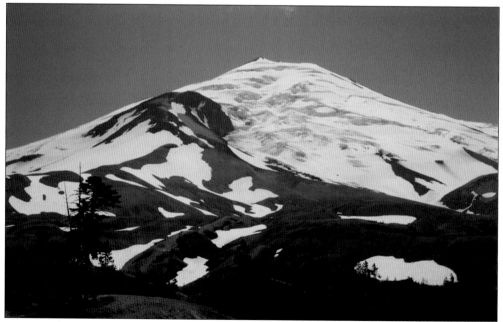

The "Dogshead Route" of Mount St. Helens is pictured here. Climbing would be mostly on the rock and scree to the snow and up from there. This photograph was taken prior to the 1980 eruption, so this route is no longer an option.

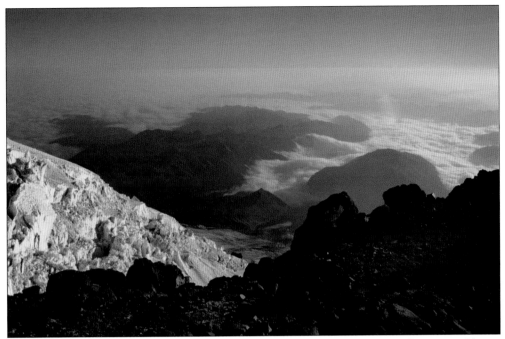

This is an early-morning view from the east side of Mount St. Helens on Shoestring Glacier while ascending towards the summit. Clouds are visible below before the sun has had a chance to burn them off.

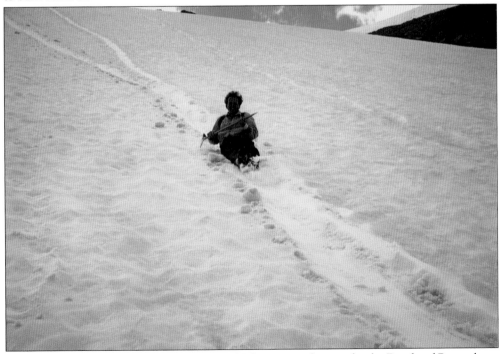

After a successful summit climb of Mount St. Helens, it was fun to take the Dogshead Route down so that the climbing party would be able to enjoy a long and safe glissade to the lower levels St. Helens is famous for. A good slide is always invigorating and a good way to end a climb.

The Mount Adams Wilderness area is home to Mount Adams, which, at an elevation of 12,276 feet, is the third highest of the Cascade volcanoes. This wilderness area offers lots of opportunity for climbers of all skill levels to climb on less crowded routes, as this area is used less due to the lack of nearby amenities.

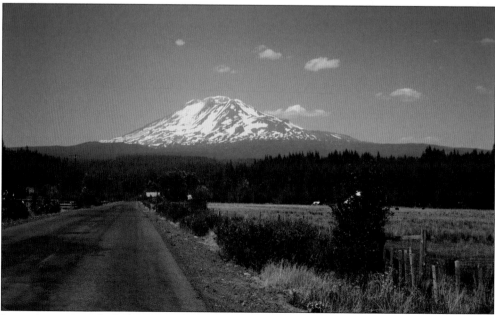

It is sometimes overlooked as a real climbing challenge because it is so far away from the population centers of the state of Washington, and it is also not a significantly challenging climb if the "Standard Route" is used. With very little experience and training, a person can get to the summit of Mount Adams if he or she is in good physical shape.

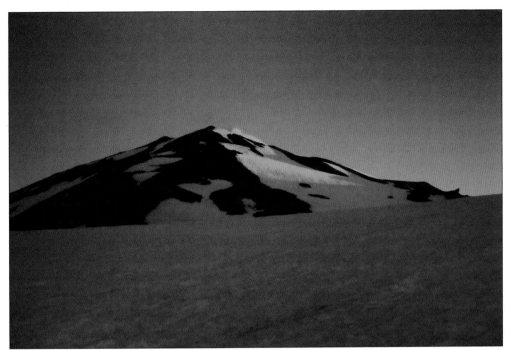

This is what a climber would be looking at not too far from base camp if approaching the climb from the southern or what is called the South Spur route. This route normally requires no glacier travel, with the majority of the travel on scree or hardened snow.

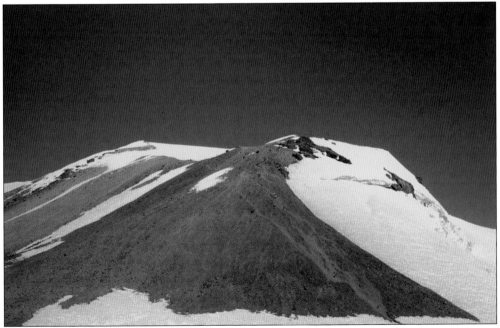

The scree travel is long and arduous, with a break about half-way up to the summit called the "lunch counter," where quite often the tired climbers will stop for a well-deserved rest before continuing on to complete their climb. The southeastern sun can be very unrelenting at this point in the climb.

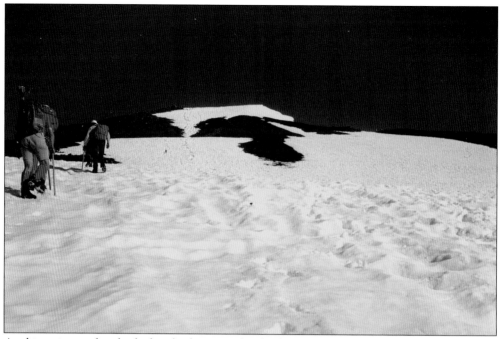

At this point in the climb the climbers may be thinking they are approaching the summit of Mount Adams but will soon be disappointed when they find what they see ahead is a false summit and their ultimate goal is still well ahead of them. These false summits are almost like a mirage in a desert at times.

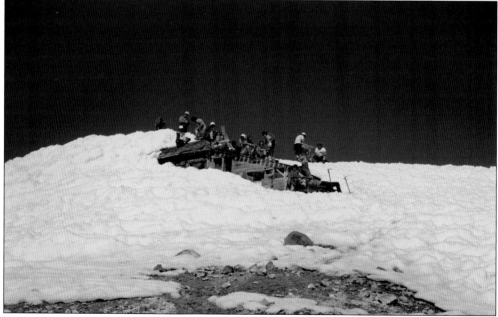

An interesting surprise near the summit of Mount Adams is an old abandoned Forest Service lookout, which was the highest-elevation lookout in the nation when it was built in 1921. It was only used by the Forest Service for a few years, and then the Glacier Mining Company used it up until about 1959. It is still there and fun to investigate if the snow has melted.

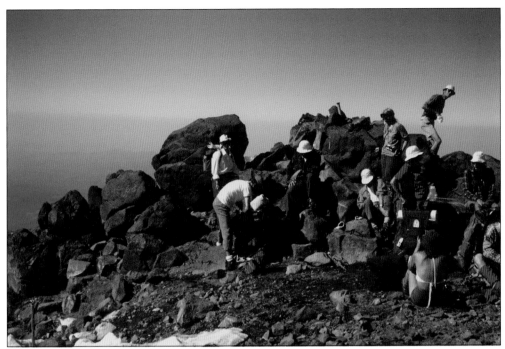

The summit has been achieved and the climbing party is enjoying its well-deserved views and rest after about nine hours of arduous climbing. The trip down will be a bit shorter, but it will be equally arduous, as they are all quite tired already from their long climb to the summit.

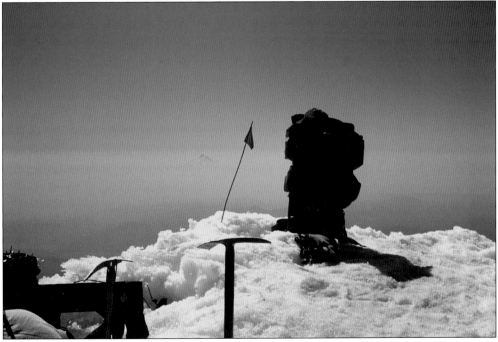

This climber is viewing Mount Hood, about 60 miles away, near Portland, Oregon. This peak is a fun challenge for Washington State climbers as it is near the border and offers many climbing challenges but also has a nice lodge to stay at for a base camp if a climber chooses.

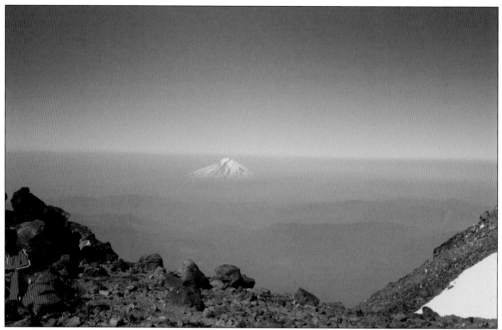

This image shows what Mount St. Helens, to the west of Mount Adams, looked like before its very famous eruption in 1980. It looks very small when a person is looking at it from a mountain the size and height of Mount Adams.

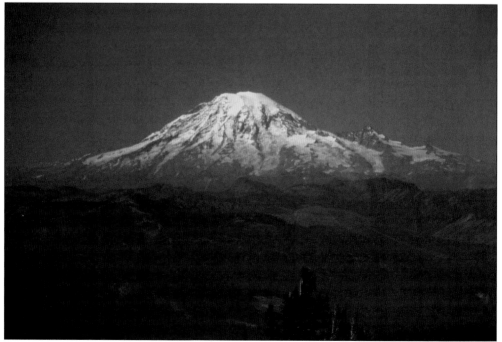

Mount Rainier is in the distance about 45 miles to the north of Mount Adams. The climbers were fortunate during this climb to be able to see these peaks in all their glory on a fine sunny day. The climate for Washington State climbs is very unpredictable over the long term, even in the summer. At altitudes over 10,000 feet there is absolutely no predictability in the weather.

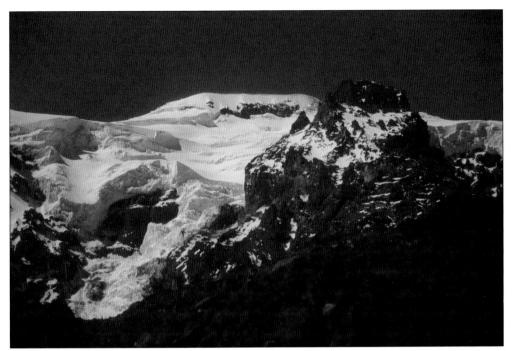

When a mountaineer wants to take a more adventurous climb up Mount Adams there is always over the "Castle," shown here between the icefall of the upper Klickitat Glacier and the headwall of the Rusk Glacier. This far less climbed route is on the southeast side of the mountain.

The Castle is shown in this photograph surrounded by a ring of clouds, indicating how fast the weather can sometimes change at higher altitudes. It was at one time thought that an ascent over this prominent feature was impossible, but it was completed by Claude E. Rusk during an outing of the Cascadians in the early 1920s.

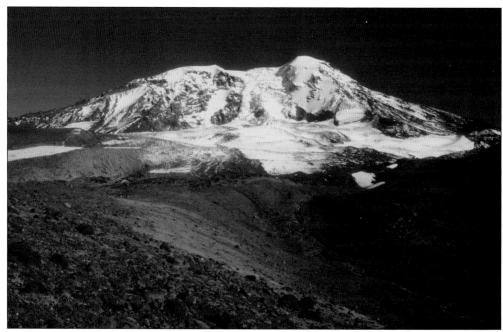

These two images show Adams Glacier on the east side of Mount Adams, which offers ice and glacier climbers all of the challenges they would like. Usually when climbers approach the mountain from this side, they will go up the right hand side of the Adams Glacier on what is called the Northwest Ridge, away from the dangers of falling ice and the navigational problems that are offered on the glacier. Going up this route, climbers will encounter the West Peak, which is called the false summit on climbs coming up the south side. The first ascent of this route was made by Fred S. Stadter, John Scott, and Lindsley Ross in 1924.

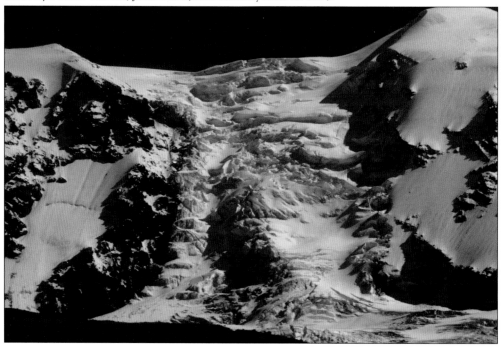

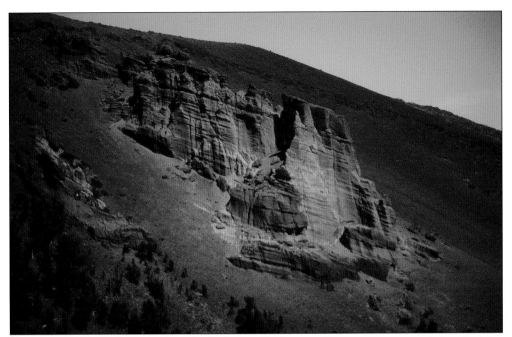

Circumventing Mount Adams, as a climber would have to do to get to some of the climbing routes, one encounters many interesting scenes, such as the rocks above. These rocks may be climbable, but they actually look more like a backdrop for a Western movie featuring early cowboy movie stars.

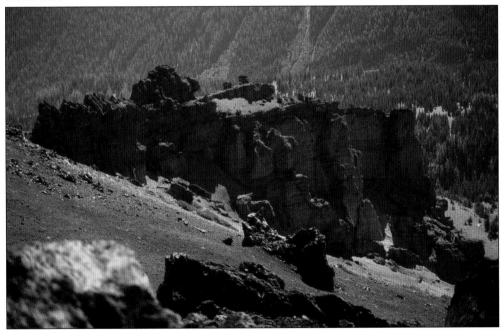

This is another image of the rocks addressed above that shows the variations of the structure of Mount Adams. The entire east side of Mount Adams is on the Yakama Indian Reservation, and climbers who are using this area are doing so on Yakama Nation's property and may be required to get a permit from them depending upon their access point.

The Goat Rocks Wilderness area is visible from the summit of Mount Adams in this image. This little-known wilderness area is near Yakima and covers over 105,000 acres. Many backpackers will pass through this wilderness area while they are doing the Pacific Crest Trail route.

At first light in the morning is the best time to begin a climb, as it is cool and the snow is solid to walk on. If crampons are used, a good grip can be had on the ice. The scenery is better then as the sun comes up with its first glow of the morning.

# BIBLIOGRAPHY

Beckey, Fred. *Cascade Alpine Guide Climbing & High Routes 1: Columbia River to Stevens Pass.* Seattle: Mountaineers, 2000.

———. *Cascade Alpine Guide Climbing & High Routes 2: Stevens Pass to Rainy Pass.* Seattle: Mountaineers, 1996.

———. *Cascade Alpine Guide Climbing & High Routes 3: Rainy Pass to Fraser River.* Seattle: Mountaineers, 1995.

———. *Range of Glaciers: The Exploration and Survey of the Northern Cascade Range.* Portland: Oregon Historical Society Press, 2003.

Eng, Ronald C. and Julie Van Pelt. *Mountaineering: The Freedom of the Hills.* Seattle: Mountaineers, 2010.

Kjeldsen, Jim. *The Mountaineers: A History.* Seattle: Mountaineers, 1998.

Molenaar, Dee. *The Challenge of Rainier.* Seattle: Mountaineers, 2011.

# Discover Thousands of Local History Books Featuring Millions of Vintage Images

Arcadia Publishing, the leading local history publisher in the United States, is committed to making history accessible and meaningful through publishing books that celebrate and preserve the heritage of America's people and places.

Find more books like this at
**www.arcadiapublishing.com**

Search for your hometown history, your old stomping grounds, and even your favorite sports team.